CLASSIC GLASS PAINTING

Inspirations from the Past

JUDY BALCHIN

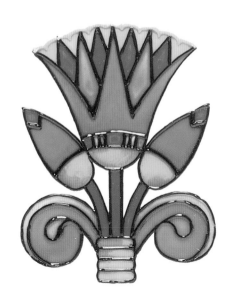

SEARCH PRESS

First published in Great Britain 1999

Search Press Limited
Wellwood, North Farm Road,
Tunbridge Wells, Kent, TN2 3DR

Text copyright © Judy Balchin 1999

Photographs by Search Press Studios
Photographs and design copyright © Search Press Ltd. 1999

ISBN 0 85532 879 7

Readers are permitted to reproduce any of the items/patterns in
this book for their personal use, or for the purposes of selling for
charity, free of charge and without the prior permission of the
Publishers. Any use of the items/patterns for commercial purposes
is not permitted without the prior permission of the Publishers.

The Publishers and author can accept no legal responsibility for
any consequences arising from the information, advice or
instructions given in this publication.

All the step-by-step photographs in this book feature the author,
Judy Balchin, demonstrating how to paint on glass. No models
have been used.

Suppliers
If you have difficulty in obtaining any of the materials and
equipment mentioned in this book, then please write to the
Publishers, at the address above, for a current list of stockists,
which includes firms who operate a mail-order service.

Colour separation by P&W Graphics, Singapore
Printed in Spain by Elkar S. Coop. Bilbao 48012

*I would like to give special thanks to John Wright of Pebeo UK
Ltd., Unit 109, Solent Business Centre, Millbrook,
Southampton, SO15 0HW, for supplying the paints used in
this book; to David Rabone of RegaLead Ltd., Sharston Road,
Manchester, M22 4TH for providing the self-adhesive lead;
and to Philip and Tacey Ltd., North Way, Walworth
Industrial Estate, Andover, SP10 5BA for supplying the Dutch
metal leaf.*

*With thanks also to Fenwick Ltd., Royal Victoria Place,
Tunbridge Wells, Kent, TN1 2SR for loaning the props
featured on pages 26, 53 and 91.*

*Special thanks to the friendly team at Search Press who have
been so enthusiastic and helpful during the writing of this
book. In particular, Editorial Director, Roz Dace for her
guidance; Editor, Chantal Porter for her hard work and
patience; Julie Wood and Liz Hayes for their creative design
skills; and Lotti de la Bédoyère for her photography.*

*Finally, thanks to all the appreciative and enthusiastic people
that I have met through my demonstrations and workshops. I
hope that you enjoy my book.*

PAGE 1
Egyptian design
*This design is a variation of the one shown on page 29. It
is worked on acetate using black outliner and vibrantly
coloured paints.*

OPPOSITE
Celtic design
*This design is worked on acetate using black and
imitation lead outliners. Once painted, gold outliner is
used to add detailing and a small glass droplet is glued to
the central motif.*

CONTENTS

INTRODUCTION

In the first century AD, craftsmen discovered the magic of painting glass. Since then, coloured glass has been used to decorate churches, cathedrals and, latterly, homes. Originally, glass-painted vessels had to be fired to permanently fix the colours to the surface, but nowadays, with the benefit of new technology, we have access to a whole range of air-drying paints that do not require firing in a kiln.

These new paints enable us to emulate classic techniques very easily. The vibrant colours can be blended together, and even textured and frosted effects can be achieved simply. Glass painting outliners are also readily available, and these can be used to reproduce the classic leaded effect in stained-glass work. Self-adhesive lead is a relatively new product on the market, and this gives an even more realistic, antique finish to a glass painted panel or window.

Each project in this book introduces a different glass painting technique. By the time you have completed them all, you will be quite familiar with the use of the paints and outliners. I also provide all the patterns required, so you do not even have to be particularly artistic to achieve stunning results. These patterns can be enlarged on a photocopier to fit your piece. Remember that colour schemes can always be altered to suit your own personal choice . . . simply photocopy the chosen design a few times, then fill it in with coloured crayons or felt-tip pens until you are satisfied with your colour scheme.

Each period in history has its own decorative style which can be interpreted by a glass painter to create beautiful pieces. This books focuses on just some of these classic periods and styles: Egyptian; Celtic; Greek and Roman; Chinese and Japanese; Art nouveau; and Victorian.

However, if you want to seek inspiration from other sources, try looking carefully at architecture or visiting museums, art galleries, libraries, churches and cathedrals. Train yourself to observe in detail – a walk in a country park or even down a busy street can spark off ideas, so it is always handy to carry a pocket book in which to jot these thoughts down. Use these ideas to create your own unique style of glass painting.

When thinking about your design, it is advisable to take into account the shape of the item you want to decorate, as this in itself can evoke a particular period. For example, a sturdy goblet would be suitable for a Celtic design, whereas a thin, delicate wine glass would not be appropriate.

Part of the fun of glass painting is hunting for suitable items to transform. If, like me, you enjoy browsing round antique and junk shops, your planning will start there. Kitchen outlets and gift shops also offer a good selection of glass items and, of course, you can recycle your own bottles, jars and plastic food containers. It is also a good idea to pay a visit to your local glazier who will be able to show you all the different types of glass in stock.

Glass painting has given me endless hours of enjoyment over the years and my home is full of bright colourful pieces, all of which have their own personal history. It is an addictive hobby, and I am sure that you will soon find yourself with boxes of glass pieces lining up to be painted. Welcome to the world of glass painting!

OPPOSITE
Art Nouveau lady
Glass paints, self-adhesive lead and black, gold and silver outliners are used to create this stunning picture.

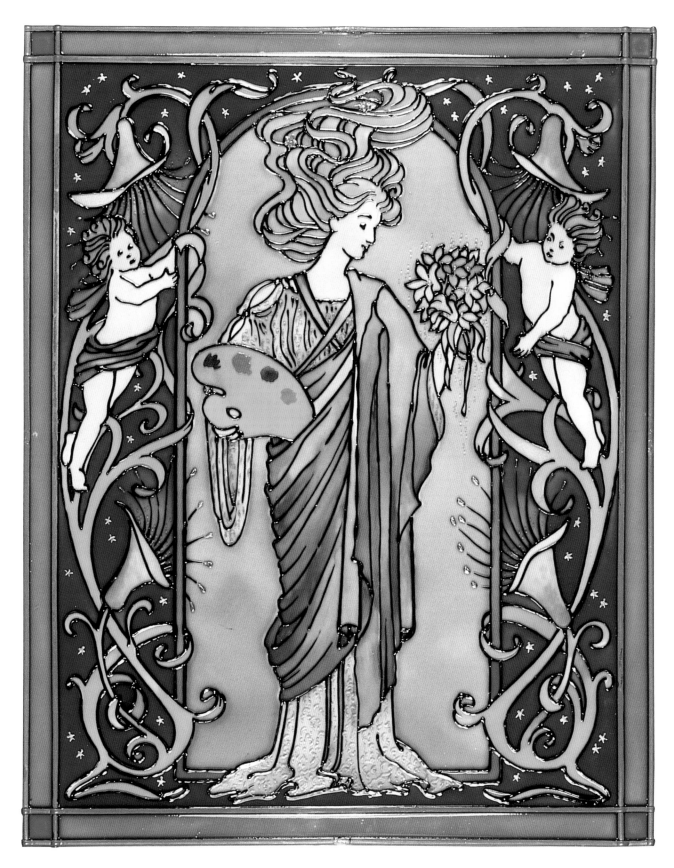

MATERIALS

The materials used in this book are all illustrated and explained on the following pages. Glass paints and outliners are available from art and craft outlets. Plain glass items can be found in junk shops, DIY and kitchen outlets, supermarkets and gift shops. Visit your local glazier for advice on plain and textured glass and of course, save any empty jars and bottles. A comprehensive list of the materials and equipment needed for the projects in this book is featured on pages 14 and 15.

Outliners

A design needs to be outlined on glass before it can be painted. There are outliners available which are specifically designed for glass painting; they are piped on to the surface and produce a raised line, which will contain the paint within specific areas. However, there are alternatives. A technical pen or permanent marker can be used for outlining, although the line produced will lie flat against the glass. A technical pen is particularly good for very detailed work. Self-adhesive lead can be applied to glass to give a more authentic stained glass appearance. This can be bent to outline simple motifs and is excellent for border work. These outliners can all be used separately or can be combined within one design as illustrated below.

Black and imitation lead outliners

Black and imitation lead outliners are used for outlining a design; the paints will not colour the outlines. These and the metallic outliners are provided in a tube fitted with a fine nozzle. Practise on paper to get used to using the tube. Lay the tip of the nozzle lightly on the surface and squeeze gently with an even pressure, while pulling the tube along the surface; this will produce an even, unbroken line. Straight lines are achieved by lifting the tube slightly as you pull. Mistakes can be wiped off with a cotton bud when wet, or scraped off with a knife when dry. Use absorbent paper to wipe away any blobs that form on the end of the nozzle.

Metallic outliners

Metallic outliners are also available and these are applied to the surface in the same way as black and imitation lead outliners. Glass paints will colour these outliners, so painting has to be done carefully. Alternatively, it is possible to outline in black, paint the design, let it dry and then work over the black outline in metallic outliner. Generally, I use metallic outliners as decoration worked on top of a completed piece – this avoids the problem of the paint colouring the outliner. Metallic outliners can also be sponged on to pieces to give extra sparkle. Squeeze the outliner on to a palette before applying it to the glass with a sponge.

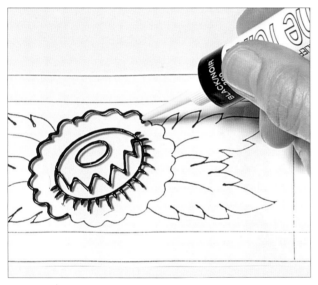

Squeeze the outliner with an even pressure to achieve a clean, unbroken line.

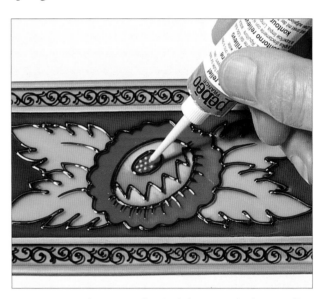

It is easier to decorate a finished design with the metallic outliners. Add dots, flowers and stars to highlight areas.

Decorative self-adhesive lead

The application of self-adhesive lead can give a glass painted piece an authentic stained-glass appearance. On application, the lead is shiny, but it gradually dulls to a lead colour. It is also available in a brass effect and a dark grey, antique lead effect.

Self-adhesive lead can be obtained from craft outlets and glaziers. It is supplied on a roll and comes in a range of widths. I have used 3.5mm (0.140in) lead for the pieces in this book; there is also a 3mm (0.120in) width lead available, which is supplied in a double ribbed strip which must be cut down the middle with a scalpel. These fine lead strips can be used to create flowers and borders and to decorate bottles. Larger projects will require a wider lead.

Self-adhesive lead has a paper backing which is peeled off to reveal the adhesive. The lead is then pressed on to the glass. Lead is supplied with a plastic boning tool – this is used for rubbing the lead flat on to the glass. You must ensure that the surface you are applying the lead on to is thoroughly clean – wipe over with lighter fluid or methylated spirit to remove traces of grease.

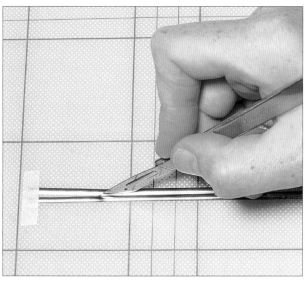

The 3mm (0.120in) lead is ribbed, and can be cut. It is difficult to hold the lead and cut it at the same time, so secure the ends with masking tape before you cut.

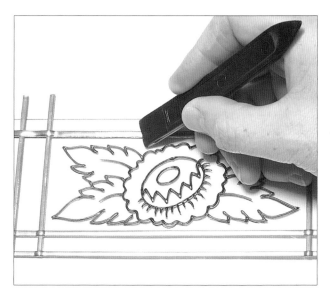

A boning tool is used to press the lead on to the surface. The tip of the boning tool should be run along the edges of the lead to prevent the paint from seeping underneath

A technical pen can be used with draughting film ink as an outliner. Alternatively, an opaque solvent-based permanent marker can be used.

Technical pen

A technical pen can be used for outlining or fine detailing. Use draughting film ink in the pen as this is designed to adhere to a smooth surface. Technical pens can be fitted with different sized nibs. I have used a 0.5mm (0.020in) nib for the pieces in this book. The line produced by a technical pen can be scratched off the surface when dry. To avoid this, work on the back of the piece (see page 23) or, if decorating an item with tracery, seal with glass paint. If using a pen to outline a design, remember that the line will lie flat on the surface. This means that you will have to apply the paint sparingly, leaving each colour to dry before moving on to the next – water-based glass paints are preferable as they dry very quickly. It is possible to use a solvent-based permanent marker instead of a technical pen. Water-based paints should be used with these pens. Gold and silver marker pens can also be used for detailing.

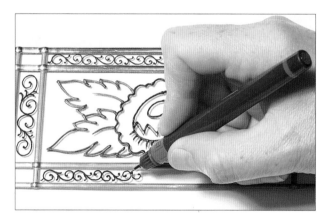

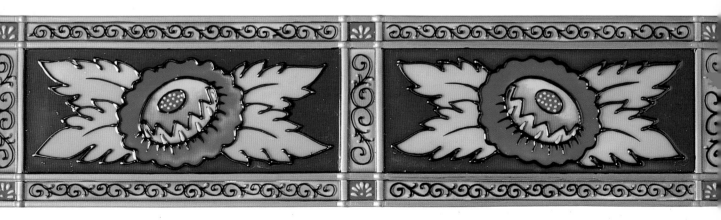

Glass paints

Glass paints are a transparent range of paints manufactured specifically for painting on glass. They are purely decorative and are not intended for use on items that need frequent washing. Both water-based and solvent-based glass paints are used in this book. Each are available in a good range of colours and are intermixable within their range. However, solvent-based paints will not mix with water-based paints.

The paints should be applied liberally straight from the bottle, and then allowed to settle flat within their defined area – this will create a smooth stained-glass effect. Painted pieces should be left to dry on a cooling rack in a dust-free area, or they should be covered with an up-turned box.

Water-based paints

Water-based paints dry quickly and have very little odour. Colours can be diluted by adding water-based clear gloss varnish to the paints. Brushes used with these paints should be cleaned in water. A water-based matt varnish is available in this range, and it can be used to achieve a frosted look. Water-based acrylic paint can be used to create a truly flat finish by painting the back of a piece of glass (see page 61) or, for instance, inside a vase (see page 64); this paint needs to be sealed with gloss varnish to protect the finish.

Glass paints are available in vibrant colours. You should not shake bottles before use, as this will create air bubbles.

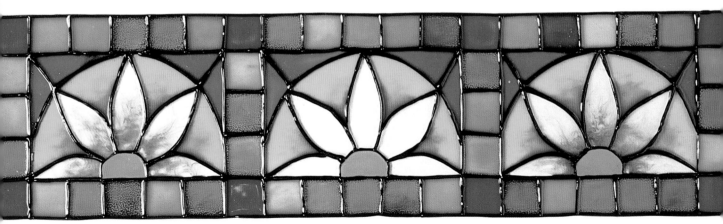

Solvent-based paints

Solvent-based paints are more durable than water-based ones and have an antique appearance. Colours can be diluted by adding solvent-based clear gloss varnish. This varnish can also be used to add protection to your finished piece. You should wait one week after painting before applying this. Brushes used with solvent-based paints should be cleaned with white spirit. It is important to work in a well-ventilated area when using these paints.

Water- and solvent-based paints should, in general, not be mixed together. However, it is possible to use the matt water-based varnish within a design that uses solvent-based paints. If you do this, ensure that the other painted areas are dry before applying the varnish.

Using white

White is the only opaque colour in the glass painting range; all the other colours are transparent. You can achieve an opaque pastel look by adding white to any of the other colours. The white and coloured paint should be mixed on a palette. White paint will separate in the bottle and the pigment will settle to the bottom, so stir it gently before decanting it. This opaque paint mixture will colour outliner, so take care when painting. If you do obscure the liner, you can re-outline the area once the paint has dried.

Paints should be applied liberally so that they settle flat within the outlined areas.

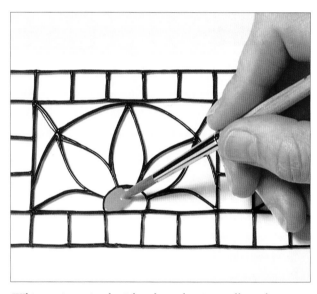

White paint mixed with coloured paint will produce an opaque effect.

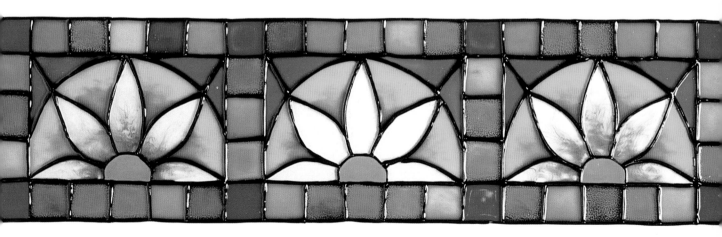

Merging and blending

Paints can be blended together on glass to produce subtle shading. This technique works best with solvent-based paints. The lightest colour should be applied liberally first. While the paint is still wet, a few dots of the darker colours are added. A paintbrush is used to pull the darker colour into the lighter colour and the colours are blended together by feathering lightly with the tip of the paintbrush.

Using matt varnish

Water-based matt varnish will produce a frosted appearance on glass. On application, it appears glossy . . . but be patient, as the frosted finish only appears as it dries. It can be used to fill in outlined sections or it can be simply painted freehand straight on to the glass. Mixed with a little coloured paint it can be sponged on to an area to create a matt pastel effect.

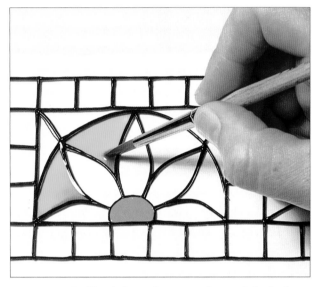

Paints can be blended together to produce subtle shading.

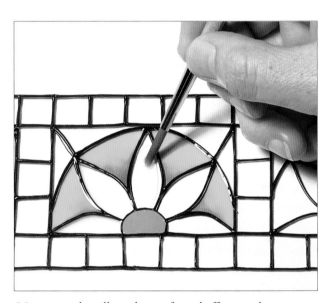

Matt varnish will produce a frosted effect on glass.

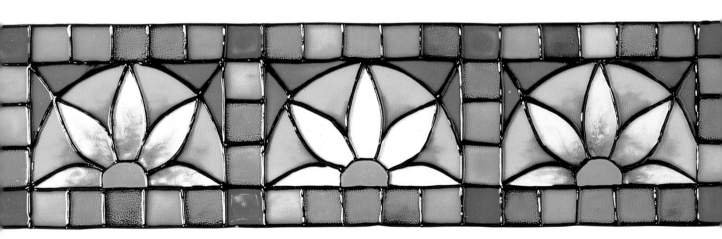

Marbling

An attractive marbling effect can be achieved using water-based matt varnish. Apply the matt varnish liberally, then, while it is still wet, drop small spots of coloured paint on to it. Pull the colour into the varnish with a cocktail stick, and use swirling strokes to create the required marbled finish. Always work on a flat surface with this technique, as the paint will run on a curved or upright area.

Using gloss varnish

Glass paints are available in rich, vibrant colours. However, for some projects these colours may appear a little dense. You can reduce the intensity and produce more pastel shades by adding a little clear gloss varnish to the paints. Mix the varnish and the paint together thoroughly but gently on a palette, before applying to the glass.

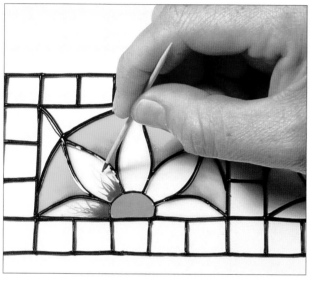

Matt varnish can be used with coloured paint to produce a marbled effect.

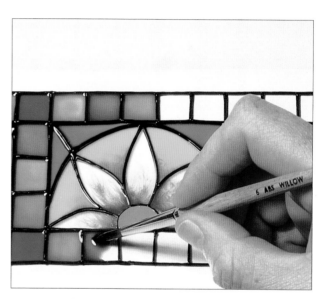

Paints can be diluted and different shades can be obtained by mixing with clear gloss varnish.

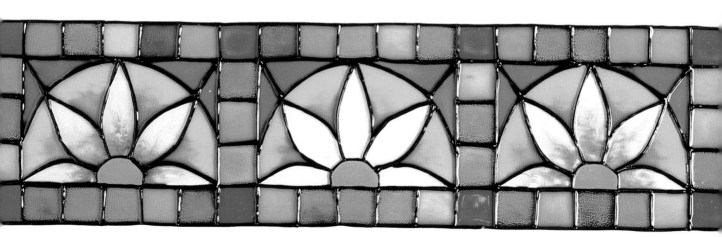

Other materials

You will not need all the items on this page to start your glass painting hobby. Each project provides you with a specific list which should be checked carefully before you begin.

1. **Cutting mat** Self-adhesive lead should be cut on a cutting mat.

2. **Adhesive tape** Used to attach patterns to glass.

3. **Masking tape** Used for securing acetate over a design, for taping self-adhesive lead down when cutting, and for masking off areas.

4. **Glass painting gel** Used to create texture on glass. It is available clear, coloured and with glitter. Glass droplets, beads and wire can be embedded into the gel while still wet.

5. **Acrylic paint** For painting the back or the inside of a piece of glass to give an opaque appearance.

6. **Synthetic round paintbrushes** Paint is applied using a No. 2, 4 or 6 soft paintbrush.

7. **Palette** For mixing paints in.

8. **Ruler** A ruler can be used to help achieve a straight line when drawing out a design with a technical pen.

9. **Pieces of sponge** For applying paint. Sponging is a good way of covering large areas with very little paint. It will produce a slightly textured effect. Synthetic sponge is ideal for this technique, and it is inexpensive.

10. **White spirit** For cleaning brushes used with solvent-based paints.

11. **Lighter fluid** For cleaning surfaces prior to painting. Methylated spirit can also be used.

12. **Water** For cleaning brushes used with water-based paints.

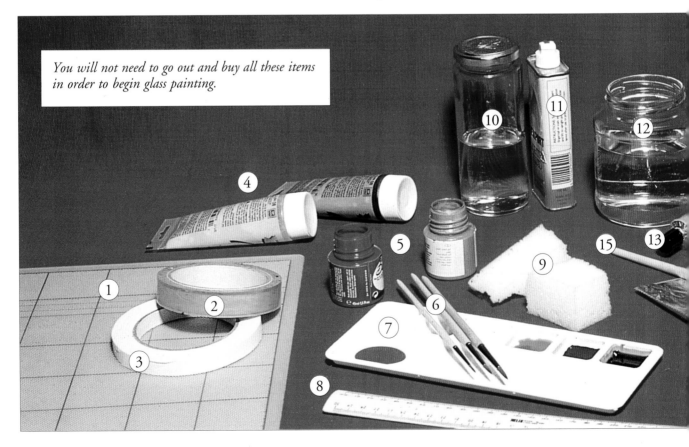

You will not need to go out and buy all these items in order to begin glass painting.

13. **Strong, clear adhesive** For attaching decorative glass droplets on to glass.

14. **Spray glue** For mounting acetate on to card.

15. **Large soft brush** Used to brush away excess leaf when gilding.

16. **Clear gloss varnish** Painted or gilded items can be sealed using clear gloss varnish.

17. **Gilding size** Size is used as an adhesive for Dutch metal leaf when gilding.

18. **Dutch metal leaf** This is used for gilding. It is available in sheets, and it comes in various metallic finishes.

19. **Scissors** For cutting out patterns and acetate.

20. **Scalpel** This is used to cut self-adhesive lead.

21. **Ballpoint pen and pencil** For transferring a design if using carbon paper.

22. **Water-based felt-tip pen** For drawing designs directly on to glass.

23. **Cooling rack** Items can be left to dry on a cooling rack.

24. **Card** For backing acetate.

25. **Tracing paper** For tracing designs.

26. **Carbon paper** For transferring designs.

27. **Absorbent paper** For mopping up spills and wiping nozzles and brushes. It is also used for cleaning surfaces with lighter fluid.

28. **Cotton buds** For wiping away mistakes made when using outliner. Also used for correcting small paint spills.

29. **Glass droplets** For adding decoration.

30. **Blanks** There are many blank items available that you can decorate (see also pages 16–19).

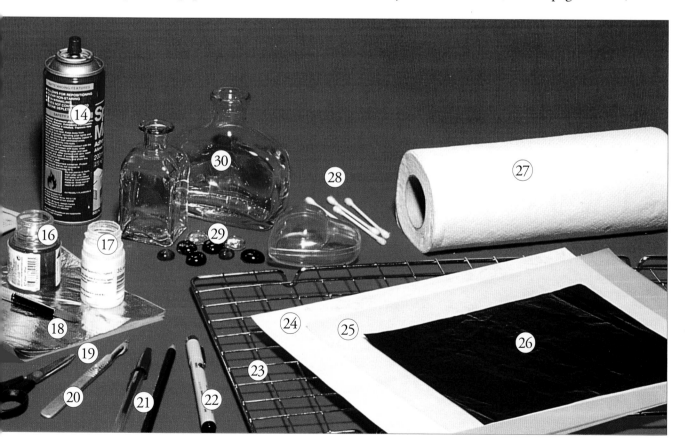

SURFACES TO PAINT

Glass paints are designed to adhere to a smooth flat surface . . . the obvious one being glass. However, acetate, plastic glass and mirror glass can also be used. In fact I have even decorated white ceramicware with glass paint – this gave an attractive enamel-like quality to the work.

Painting on a horizontal surface is far easier than painting on a vertical or curved surface. If you are just beginning to glass paint, acetate is an ideal starting point. Designs can be painted flat, then cut out and applied to windows for decoration. You can then move on to inexpensive glass clip frames or flat, shaped window hangers – both are easy to decorate and make ideal gifts. Next, try a plate or perhaps a flat-sided vase. By the time you start painting on a curved surface such as a vase, goblet or bowl, you will have become familiar with using the paints.

Vases and bowls should be laid on an old towel for painting. Glass paint does run and you will find it easier to paint one section of your piece at a time, then leave this to dry before moving on to the next. Painting a window or door panel in situ is difficult. If possible, remove the door or window so that you can work on it horizontally. Alternatively, ask for a piece of glass to be cut to the size of the window or door panel, decorate it and then fit it on top of the existing panel with beading. Leave for a week before applying a protective coat of glass painting varnish.

All surfaces should be wiped over with lighter fluid or methylated spirit before decorating them, to remove any traces of grease.

Remember that glass painted pieces are purely decorative and should be handled with care when cleaning. Wash in cold water to remove any dust particles and dry with a soft cloth.

Glass

Glass is the ideal surface to decorate with glass paints. It is cheap, durable and can be cut to size at a glaziers. Ask for the edges of the glass to be smoothed for safety, or run a strip of tape around them. Glass comes in different thicknesses – 2mm (0.080in) glass is sufficient for a glass painted picture. Glass used in windows or doors must conform to government safety guidelines. Your local glazier will be able to advise you on these.

An excellent selection of glass items is also available – from picture frames to vases, bottles and plates.

OPPOSITE
This selection of painted glass illustrates just some of the different effects that can be achieved with today's glass paints.

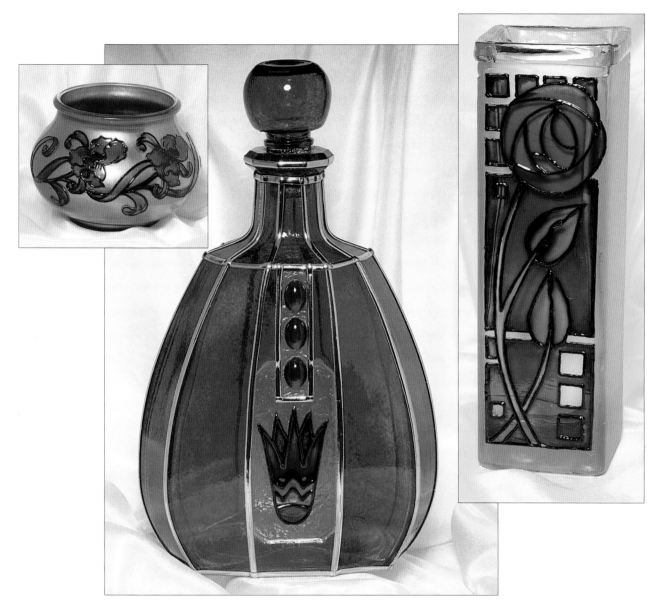

Acetate

Acetate is the easiest and most inexpensive surface to practice painting on. It can be bought by the sheet or in a pad from art and craft outlets. It comes in different weights, but 250 microns is ideal for decoration as it is thick enough to maintain a flat surface when painted, yet it is easily cut with scissors. The advantage of using acetate is that you can cut out your painted piece for display. Window decorations and mobiles painted on acetate can be stunning. Acetate designs can be mounted on, or backed with, card to create greetings cards, gift tags, book marks and much more.

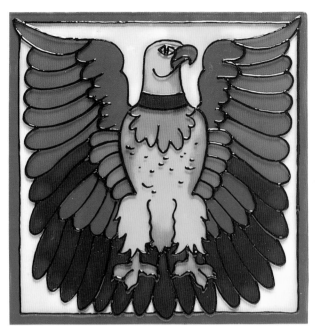

Plastic glass

Acetate

Plastic glass

Plastic glass is more expensive than glass, but it is lighter and less fragile. Once painted, it looks just like glass. For most purposes, 4mm (0.160in) thickness is ideal. Your local suppliers will cut it to size. Plastic glass is easily scratched and has to be handled carefully.

Thin clear plastic is often used for food and drink packaging. Keep an eye open for unusual shapes that can be cut out and painted. Clear plastic drinks bottles and chocolate or sweet containers are ideal. Plastic lampshades can also be decorated.

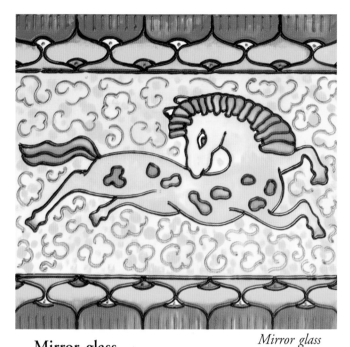

Textured plastic glass

Clear textured sheets of plastic used for glazing sheds and garages can be painted. This type of plastic is textured on one side but you can paint on the smooth side. When held against the light, it takes on a jewelled appearance. Small pre-cut shapes of this textured plastic are available from art and craft stores, or you can get pieces cut to size at your local suppliers.

Mirror glass

Mirror glass

Mirror glass can be cut to size at your local suppliers and finished pieces can then be framed. Alternatively, ready-framed mirrors can be bought and decorated, and mirror tiles are also available. A painted mirror will reflect the glass paints themselves, creating an almost three-dimensional effect. Designs can be transferred on to the surface with carbon paper and these carbon lines can later be removed with a cotton bud. If reflections are a problem when painting, use paper to mask off any areas that do not require decorating, to minimise the distraction.

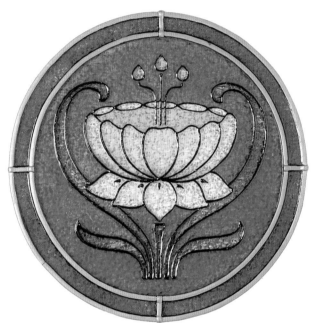

Textured plastic glass

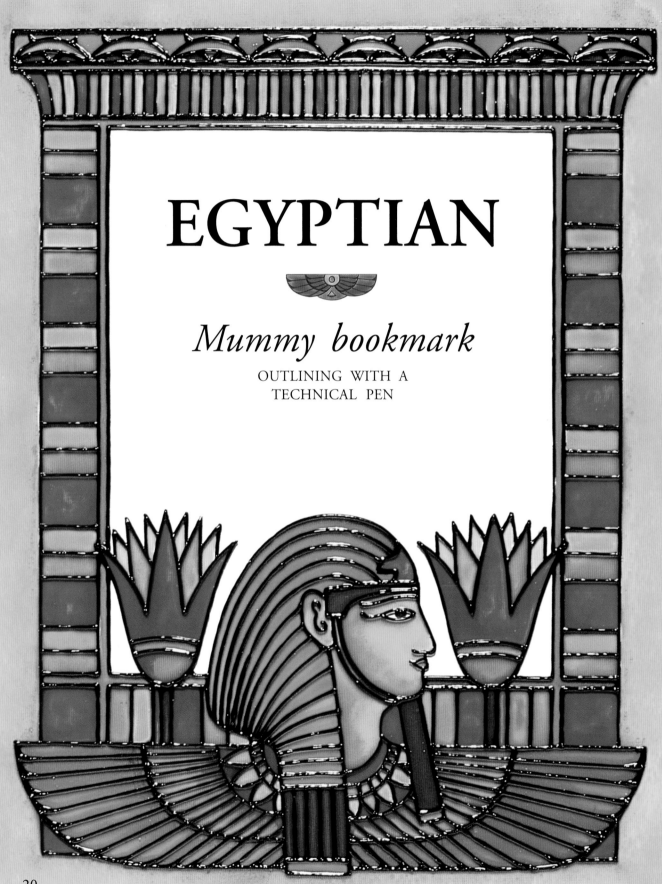

EGYPTIAN

Mummy bookmark

OUTLINING WITH A
TECHNICAL PEN

The Ancient Egyptian civilisation is one of the oldest in the world, dating from circa 3000BC. It grew up on the banks of the River Nile and lasted for more than three thousand years. The Egyptian craftsmen decorated their architecture and artifacts with beautifully painted depictions of everyday life. Hunting, feasting, farming, ceremonial and religious events were all recorded in great detail. Their work contains a vivid selection of colours, including vibrant reds, blues, yellows and greens.

The mummy is probably the most well-known image from this period. The Egyptians believed that the mummy case would magically protect the body on its journey to the afterlife. The case was often decorated with spells and symbols such as the scarab beetle. The internal organs were preserved separately in Canopic jars which were fashioned in the shape of Egyptian gods. The lotus flower symbol was used to decorate architectural columns and it represented the re-germination of nature. Even their written language was made up of individual symbols, each symbol representing an idea. The decoration used in this period provides a wealth of inspirational material. Their technique of using outlined designs filled in with a wash of colour translates easily into glass painting, and the richness of glass paint enhances the strong symbolic designs.

MUMMY BOOKMARK

Outlining with a technical pen

This first project introduces you to working on acetate with a technical pen. A technical pen produces a very fine line, which is ideal when working on an intricate design such as this bookmark. Do make sure that you use draughting film ink as this is specifically designed to adhere to a smooth surface.

All the decoration on this piece is protected, as the painted side of the acetate is glued to a backing card.

Before you begin, photocopy the design on to plain paper.

You will need

Acetate (250 microns), 8 x 23cm
(3 x 9in)

Cream card, 8 x 23cm (3 x 9in)

Technical pen, fitted with
0.5mm (0.020in) nib

Draughting film ink

Water-based glass paints:
crimson, golden yellow, orange,
bright blue and green

No. 2 paintbrush

Masking tape

Scissors

Ruler

Spray glue

Hole punch

Thin red ribbon

Absorbent paper

Lighter fluid

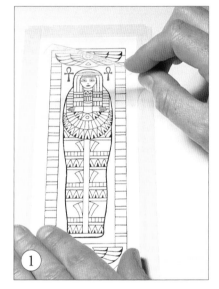

1. Tape the design on to a flat surface using strips of masking tape. Tape the piece of acetate over the design.

Note: Ensure you tape the acetate down firmly on all sides as acetate can bow when it is being painted.

Full-size pattern for the Egyptian bookmark

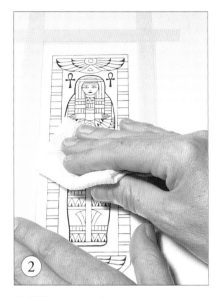

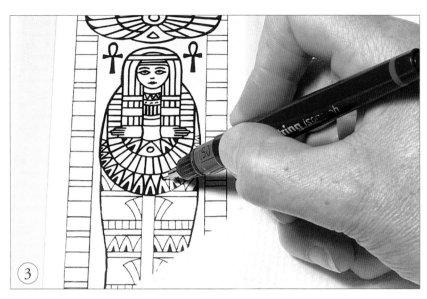

2. Wipe over the acetate with lighter fluid to remove any traces of grease – this will ensure that the draughting film ink will adhere to the acetate.

3. Use a technical pen and draughting film ink to trace the design on to acetate. Start at the top of the design and work down, drawing in the top border first, then the mummy. Use a ruler to draw in the side borders. Rest your hand on a piece of absorbent paper as you work – this will prevent you from getting grease on the acetate.

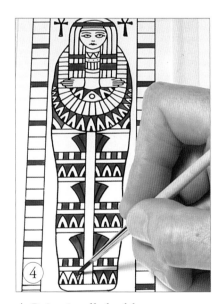

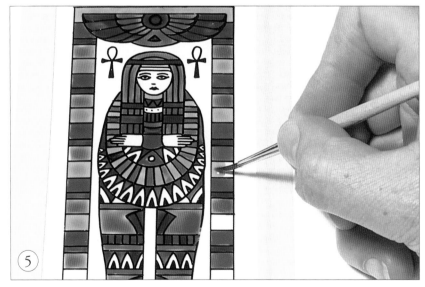

4. Paint in all the blue areas using a No. 2 paintbrush. Leave to dry. The paints dry very quickly so you will not have to wait long!

5. Next, fill in all the green areas and leave to dry. Continue filling in the design in this way, using the crimson, orange and yellow paints. Leave to dry. Leave the face and hands and the background area behind the mummy unpainted.

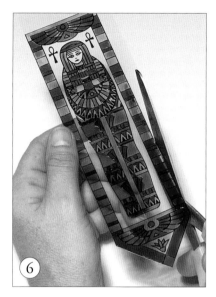

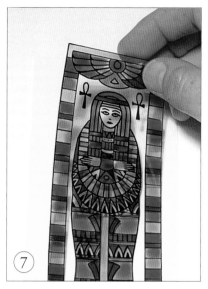

6. Use scissors to cut up to and around the outer black line of the bookmark.

7. Place the bookmark painted side up on a sheet of absorbent or scrap paper. Spray the bookmark with spray glue and press it firmly on to the cream card. Leave for a few minutes to harden before cutting off any excess card.

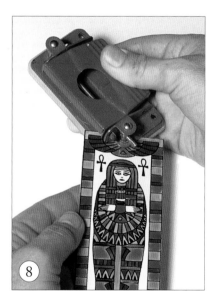

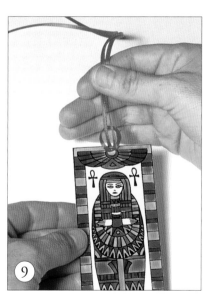

8. Use a hole punch to make a hole in the top of the bookmark, aligning with the hole in the design.

9. Form the ribbon into a loop. Thread the loop through the hole and bring the ends through to secure the knot.

Mummy bookmark
A technical pen makes an ideal outliner for an intricate design such as this. The design is backed with card, which means that the paint is protected and the surface of the bookmark can be wiped clean. The Japanese book mark on page 96 is made using the same techniques.

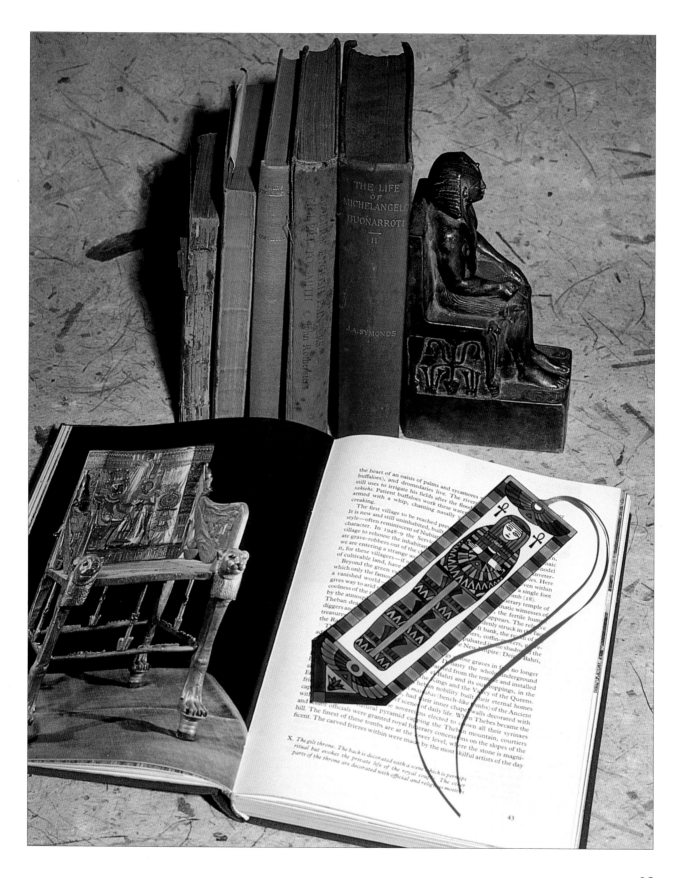

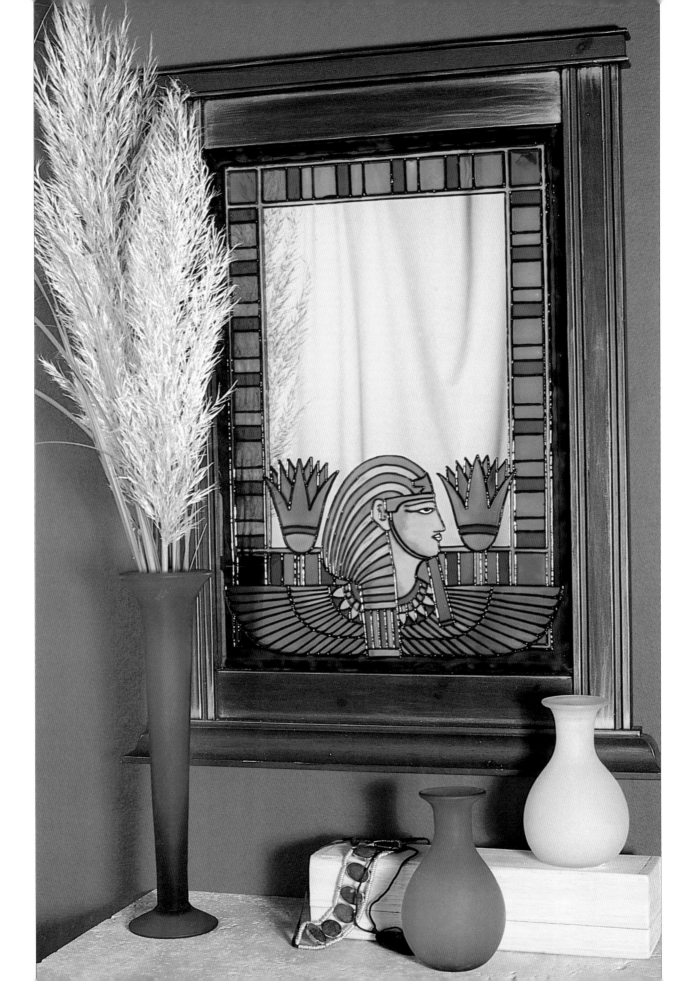

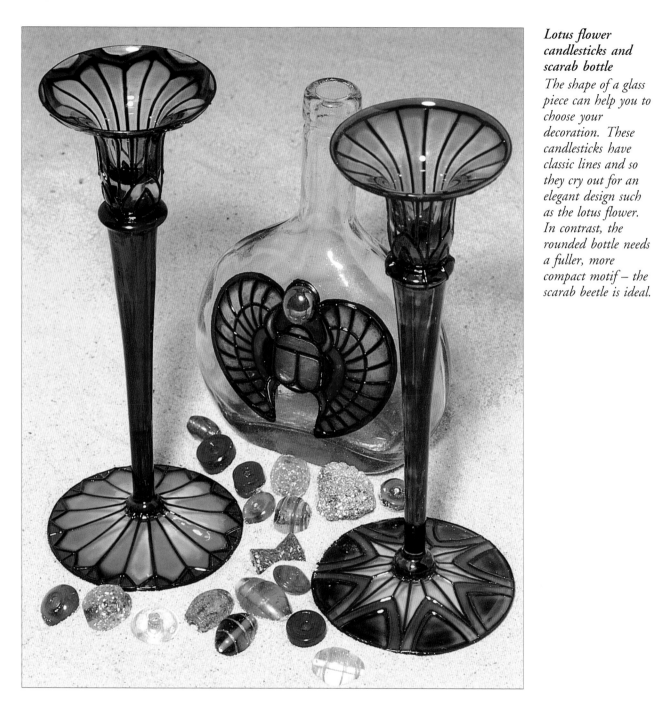

Lotus flower candlesticks and scarab bottle

The shape of a glass piece can help you to choose your decoration. These candlesticks have classic lines and so they cry out for an elegant design such as the lotus flower. In contrast, the rounded bottle needs a fuller, more compact motif – the scarab beetle is ideal.

OPPOSITE

Egyptian mirror

Patterns can be enlarged to any size. This mirror is quite large, approximately 70 x 50cm (27½ x 19¾in). It is outlined with black outliner and filled in with vibrant colours.

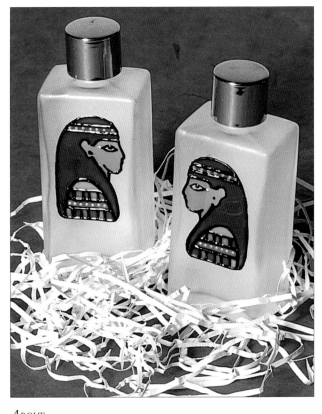

ABOVE
Sons of Horus perfume bottles
Inexpensive plain bottles can be transformed with matt varnish and a simple design painted with vibrant colours.

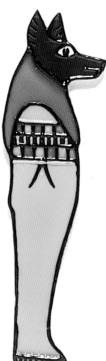

LEFT
Sons of Horus fridge magnets
It is easy to create your own fridge magnets. Work on acetate, back with card and then simply glue a magnet into place.

OPPOSITE
Lotus vase, card and bottle
This photograph illustrates the use of the lotus flower motif on a range of items. The basic design can be made more elaborate for larger pieces.

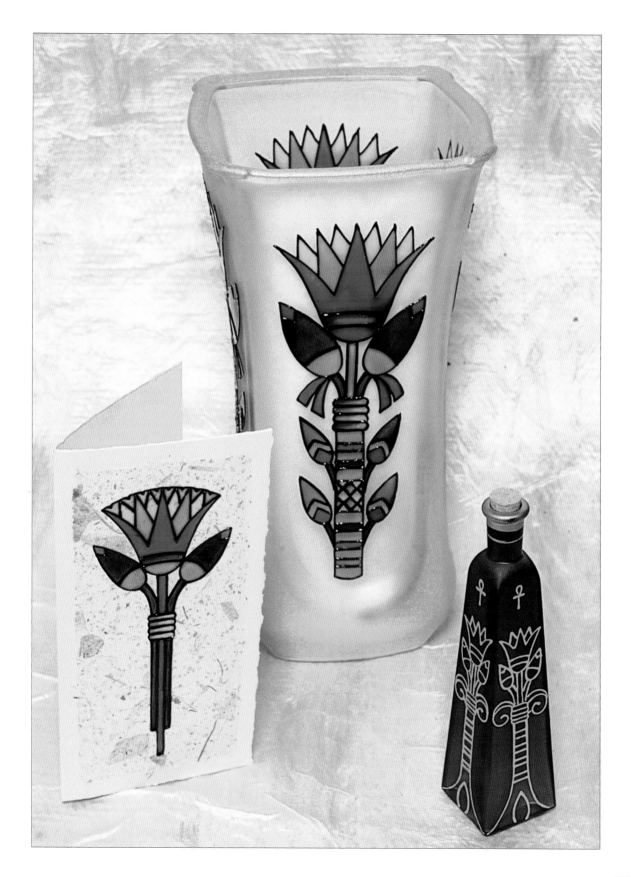

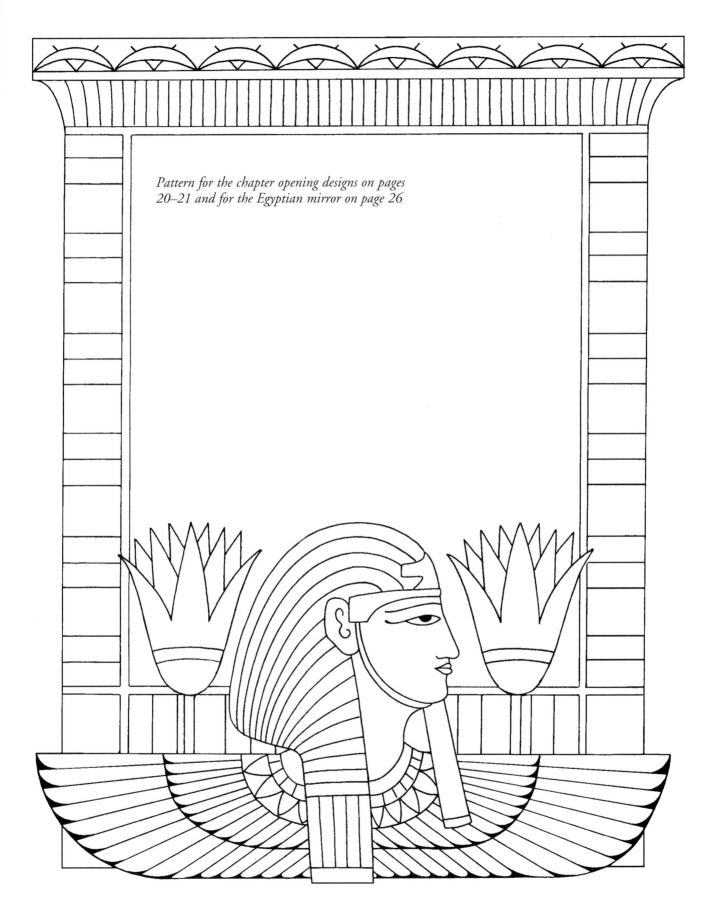

Pattern for the chapter opening designs on pages
20–21 and for the Egyptian mirror on page 26

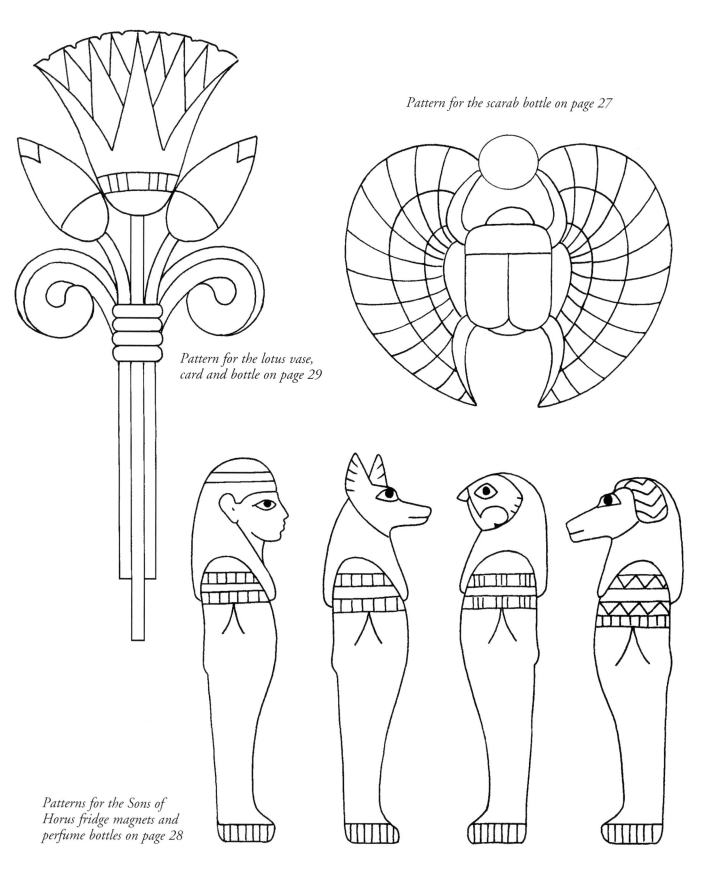

Pattern for the scarab bottle on page 27

Pattern for the lotus vase,
card and bottle on page 29

Patterns for the Sons of
Horus fridge magnets and
perfume bottles on page 28

CELTIC

Knotwork clip frame

BLENDING, USING OUTLINER
AND ADDING A GEM

The Celts were at their strongest in 300BC when their lands stretched from Ireland to Turkey and from the Mediterranean to the Baltic Sea. They became the first civilisation of Europe and in fact created the European, British and Irish nations. Celtic craftsmen were extremely skilled and held in high esteem in their clans. Their economy was based mainly on pastoral and agricultural activities, but they also produced beautiful jewellery, casting intricate designs in bronze, gold and occasionally silver. They fired brightly coloured enamel pieces to add colour and richness to warriors' costumes and chariots. Their work was generally bold and bright, and it was also often incredibly intricate. It was their belief in gods and spirits that provided much of the inspiration for their beautiful artworks.

The most well known motifs connected with the Celts are Celtic knots. These knots were used by Irish monks, along with symbolic animals, to fill in spaces around capital letters in the *Book of Kells*. The knots, with their entwined patterns and unbroken lines, are thought to symbolise man's eternal spiritual growth. The bold black outlines of these designs were filled in with vivid colour, providing an excellent basis for glass painting work. The addition of glass beads and droplets to painted pieces in this chapter adds a more three-dimensional quality to the work.

KNOTWORK CLIP FRAME

Blending, using outliner and adding a gem

Learning to control the outliner is an essential part of glass painting. Try practising on paper until you can achieve a smooth even line, but remember that the lines do not have to be perfect . . . once painted, slight imperfections are less noticeable.

The paint should be applied liberally to achieve the truly flat finish required for this Celtic design. Once it is dry, a gem is added for that final flourish.

Before you start, photocopy the design.

You will need

Clip frame, 20 x 25cm (8 x 10in)

White paper

Solvent-based glass paints: red, dark blue, turquoise, yellow, orange and green

Black outliner

No. 4 paintbrush

Cotton buds

Red glass droplet

Strong clear glue

~

Note: *For this project, you will need to place the outlined glass on top of a sheet of white paper while you are painting. Clip frames often have a sheet of paper inside which is white on the reverse and is ideal for this purpose.*

~

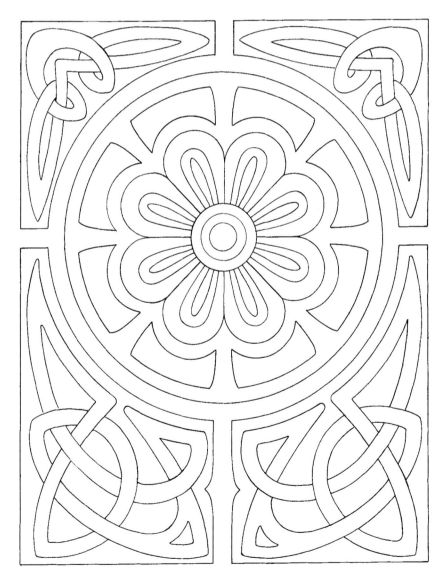

Pattern for the knotwork clip frame
Enlarge on a photocopier by 170%.

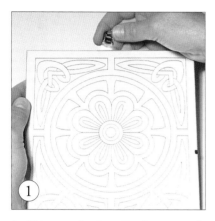

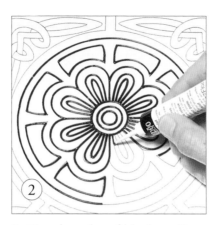

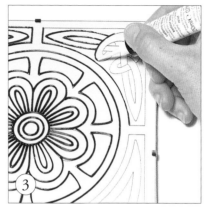

1. Dismantle the clip frame and place the pattern under the glass. Reassemble the clip frame.

2. Use the tube of black outliner to carefully outline the central flower motif. Work around each flower petal and add the circular outer border. Leave the outliner to dry for half an hour.

3. Outline each corner Celtic knot. Turn the clip frame as you work, so that the knot is nearest you – this will prevent smudging. Leave the outliner to harden.

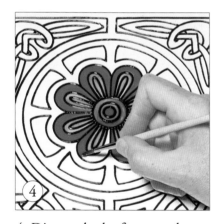

4. Dismantle the frame and remove the pattern. Place the glass over a sheet of white paper. Paint the flower centre using first red, then green, then turquoise. Paint the inner petal sections orange, the middle sections turquoise and the outer sections red.

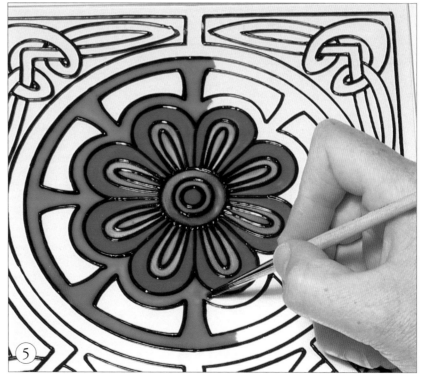

5. Fill in the border around the flower in green.

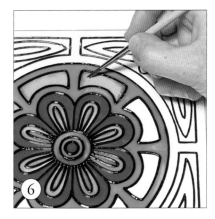

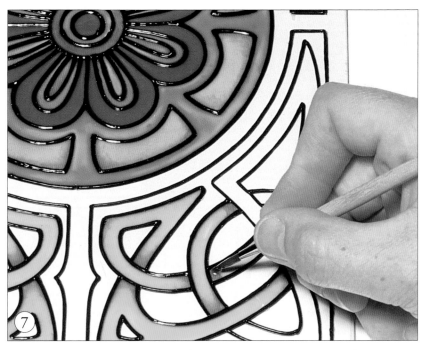

6. Now paint each section between the green border. Begin by filling in with yellow. While the paint is still wet, add a line of orange around the edge. Use your paintbrush to gently pull the orange into the yellow until the paints merge and blend. Repeat until all the sections are filled in.

7. Use the same technique as shown in step 6 to paint in the corner Celtic knots. Create shading by blending orange where one area of knotwork crosses another.

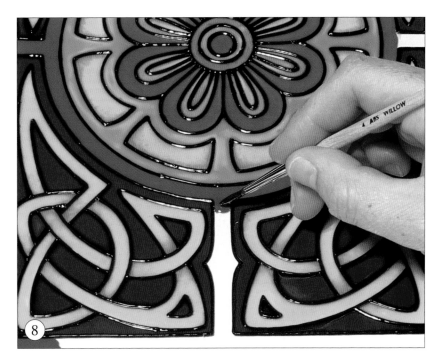

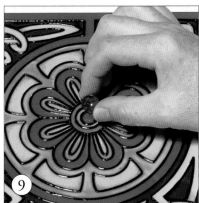

9. Finally, glue a red glass droplet on to the centre of the flower. Leave to set.

8. Fill in the background areas using dark blue. Leave to dry. Fill in the remaining borders in red. Leave to dry.

Knotwork clip frame
*The rich vibrant colours and strong black outlines found in Celtic designs are
ideal for glass-painted projects. Celtic knots can be intricate and do demand
good control of the outliner. Persevere . . . the results are well worth it!*

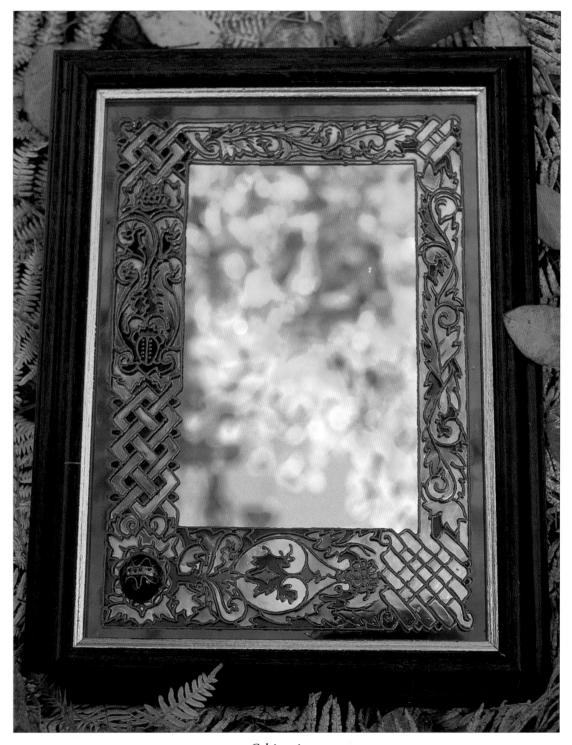

Celtic mirror
*This Celtic border design is enhanced by the use of imitation lead
outliner, and by the simple addition of a glass droplet.*

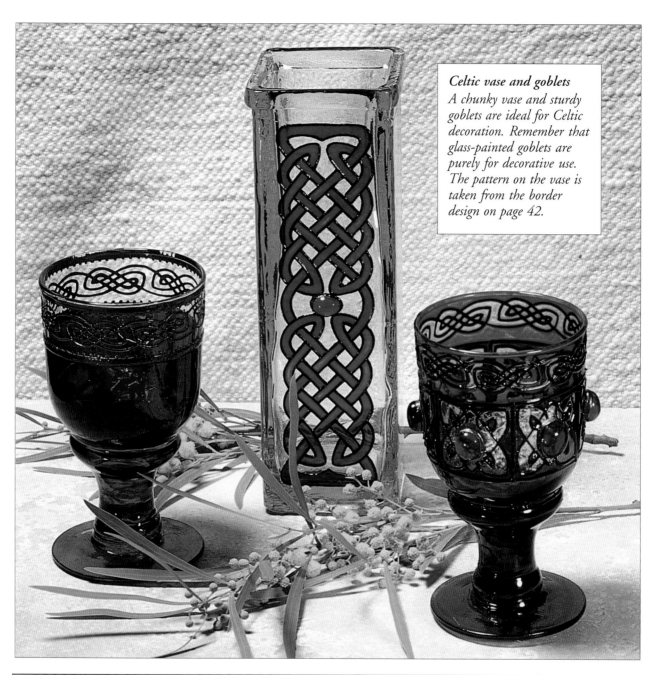

Celtic vase and goblets
A chunky vase and sturdy goblets are ideal for Celtic decoration. Remember that glass-painted goblets are purely for decorative use. The pattern on the vase is taken from the border design on page 42.

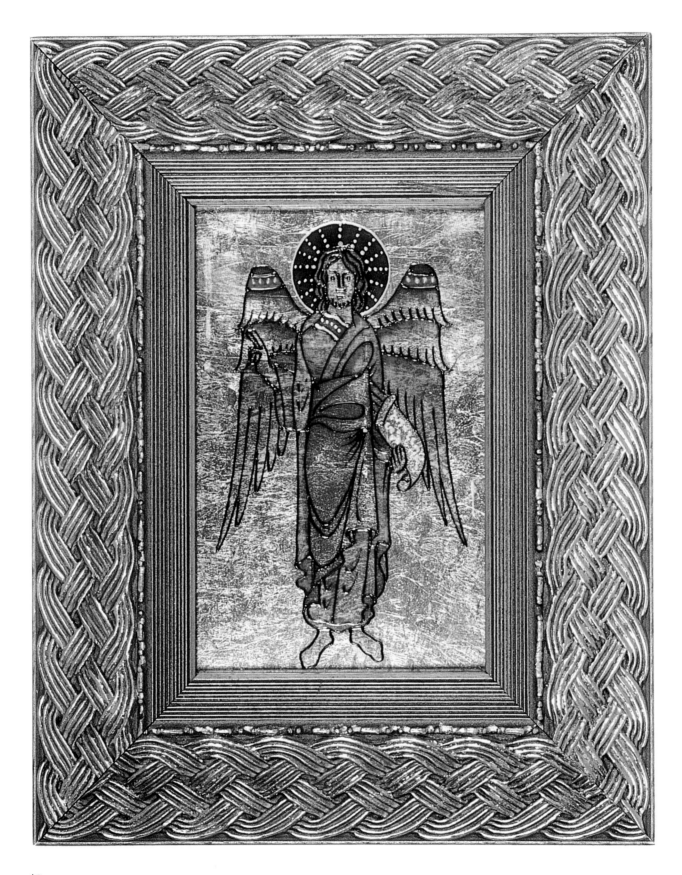

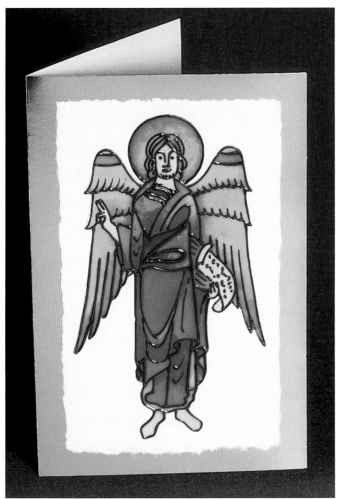

Celtic angel card
An unusual greetings card can be created very simply with a piece of acetate and some gold card.

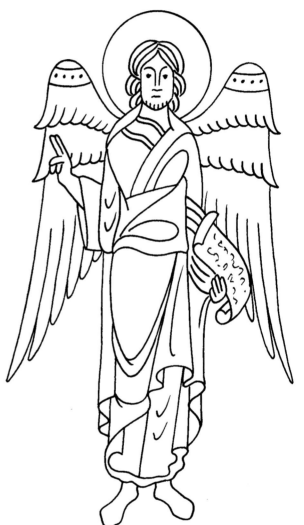

Celtic angel picture
The back of the painted glass is gilded (see page 60) to give a stunning finish to this simple design. Notice how the picture frame has been chosen carefully to reflect the period.

Pattern for the chapter opening designs on pages 32–33

Pattern for the Celtic mirror on page 38

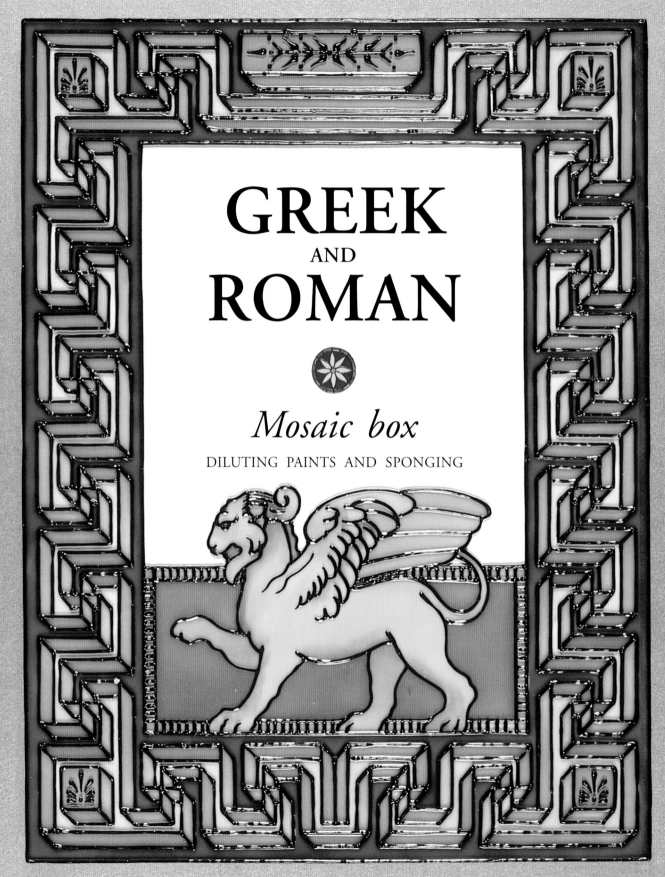

GREEK
AND
ROMAN

Mosaic box

DILUTING PAINTS AND SPONGING

Greek art and architecture date back to 1100BC. Amazingly, the Classical Greek civilisation lasted less than two hundred years (from 475–325BC), but it brought with it great advances in science, literature and art. Although no Greek paintings survive today, the sculpture reveals their understanding of the anatomy of the human figure, and their appreciation of its beauty. Greek craftsmen used mosaic as decoration – they began by using small coloured pebbles to create designs, then they moved on to using small cubes of stone.

The Romans developed this technique. They decorated their floors first with geometric designs and later they combined these designs with more ornate depictions of birds, flowers and images from their everyday life. Artifacts were commonly decorated with motifs such as acanthus, laurel and vine leaves.

Both the Roman and Greek civilisations had their own gods. They held festive days throughout the year in their honour. The Greek god of wine was called Dionysus, the Roman god was Bacchus and they were celebrated during lavish banquets.

This chapter brings together the classic design of the Greek culture with the pomp and ceremony of the Roman civilisation, using glass paints to transform a window and a variety of glass vessels, including an urn, a pitcher and a vase.

MOSAIC BOX

Diluting paints and sponging

This project shows how easy it is to transform a plain white cardboard box using some acetate, outliner and a few glass paints. Clear gloss varnish is used in the mosaic design to vary the density of the colours – in this way, a more subtle effect is achieved. I have created a slightly textured appearance on the base of the box by sponging with glass paints. You do not need to use a natural sponge for this technique – a small piece of an inexpensive synthetic one is ideal.

For this project, you need to begin by photocopying the patterns below. Photocopy the border panel twice, then tape the two patterns together to form a 31.5cm (12½in) strip.

You will need

Circular white cardboard box, 10cm (4in) diameter

Acetate (250 microns), 12cm (4½in) square and 35 x 3cm (14 x 1¼in)

White paper

Solvent-based glass paints: yellow, orange, red and blue

Clear gloss varnish

Black outliner

No. 2 paintbrush

Small piece of sponge

Masking tape

Spray glue

Palette

Scissors

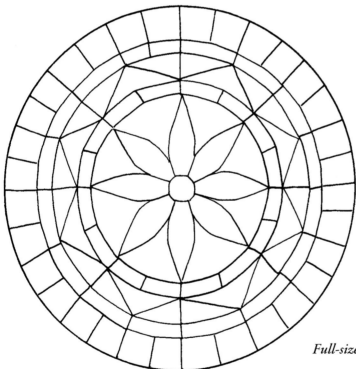

Full-size patterns for the mosaic box

46

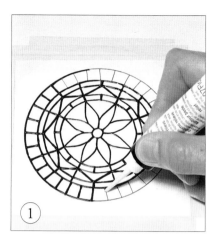

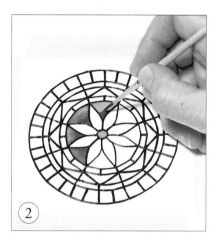

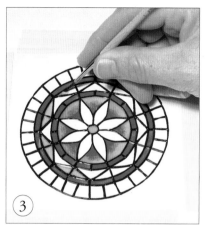

1. Tape the pattern to a flat surface. Lay the square of acetate over the design and tape the edges with strips of masking tape. Outline the design in black outliner. Leave to dry. Remove the pattern and tape the outlined design flat on to a piece of white paper.

2. Use a No. 2 paintbrush and orange paint to fill in the flower centre. Paint the sections between the petals one by one. Begin by filling in with yellow, then, while the paint is still wet, add a dot of red where the petals meet. Use your paintbrush to pull the red into the yellow to blend the colours.

3. Paint the two narrow circular borders in red and the small triangles between in orange. Leave the large triangles unpainted – these and the petals will appear white when in position on the box.

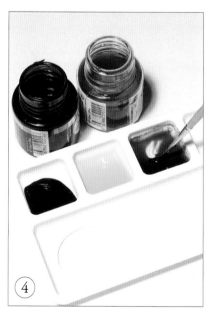

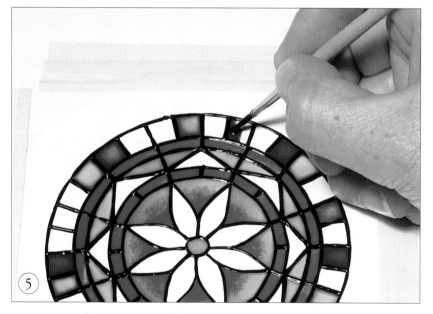

4. Place a pool of blue paint and a pool of clear gloss varnish on a palette. Mix them together gently to lighten the colour.

5. Paint random squares of the outer mosaic border using the diluted blue paint. Vary the shades of the squares by adding more varnish or paint. Continue painting in squares until the border is complete. Allow to dry.

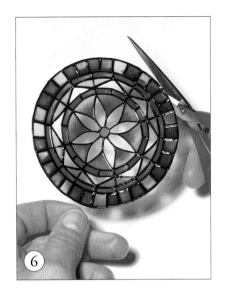

6. Cut around the outside edge of the design with scissors.

7. Lay the border pattern under the strip of acetate. Tape into position and outline with black outliner. Remove the pattern and place a piece of white paper underneath the acetate. Tape in place then paint the blue segments using the same technique as shown in steps 4 and 5. Allow to dry before cutting around the design.

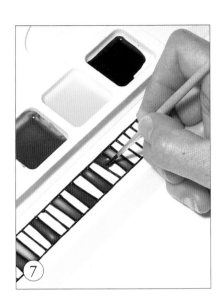

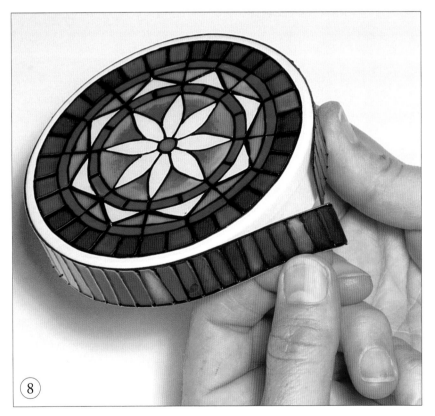

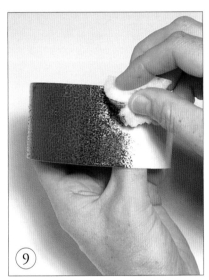

9. Pour a little blue paint into your palette. Dab a sponge into the paint and then sponge the colour on to the sides of the box. Leave to dry.

8. Lay each piece of painted acetate face down on a sheet of paper. Spray the back of the acetate with spray glue then press each piece into place on the lid of the box.

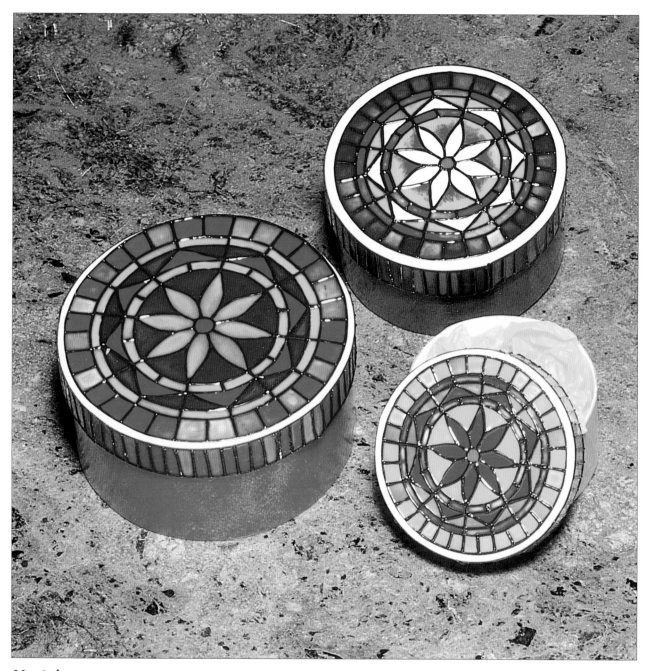

Mosaic boxes
You can use the techniques shown in the project to create a collection of mosaic boxes in different colour combinations. Remember that if you use acetate in this way, you can decorate a variety of containers which are not made of glass – look out for unusual items to transform.

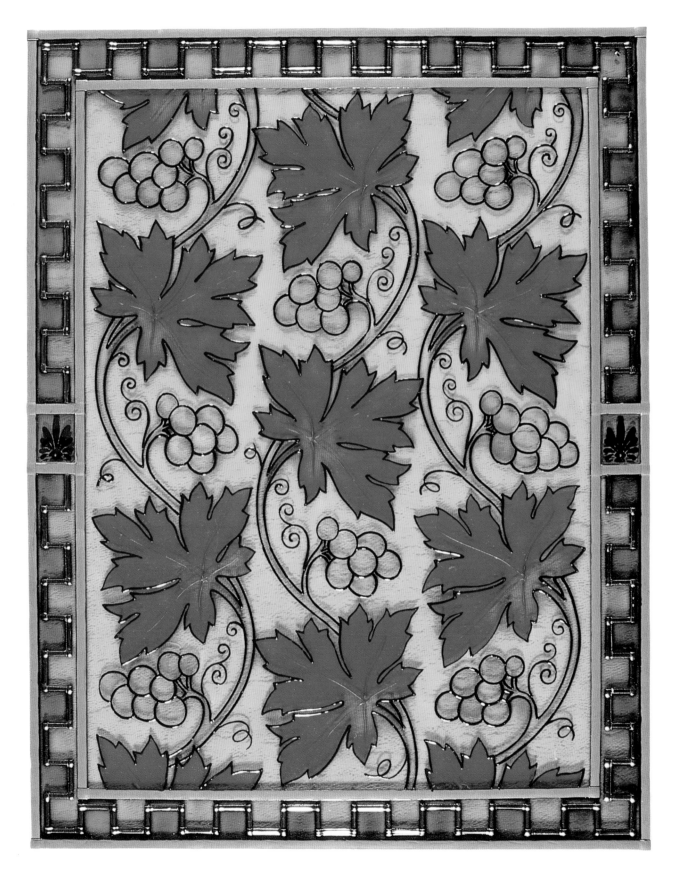

50

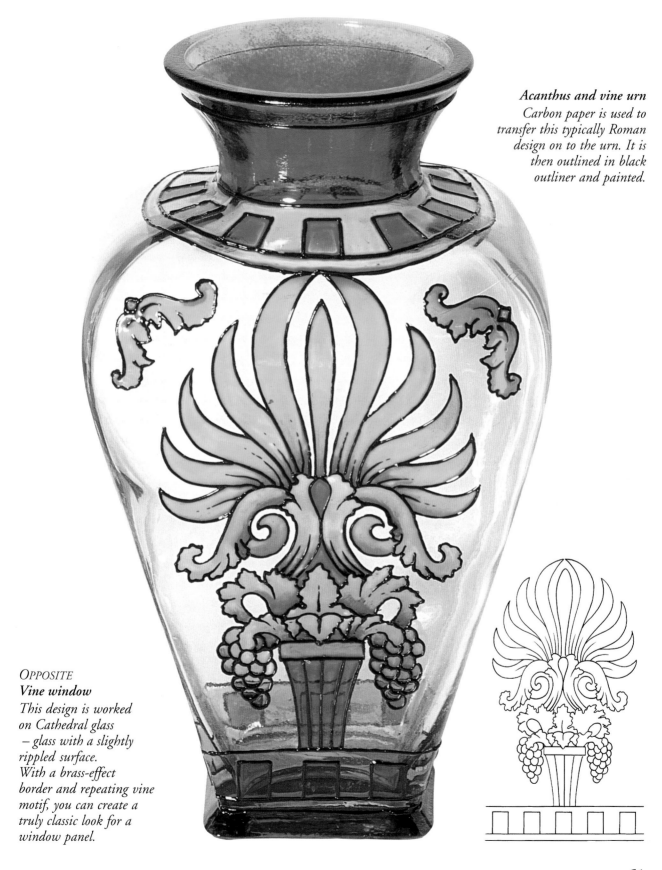

Acanthus and vine urn
Carbon paper is used to transfer this typically Roman design on to the urn. It is then outlined in black outliner and painted.

OPPOSITE
Vine window
This design is worked on Cathedral glass – glass with a slightly rippled surface. With a brass-effect border and repeating vine motif, you can create a truly classic look for a window panel.

51

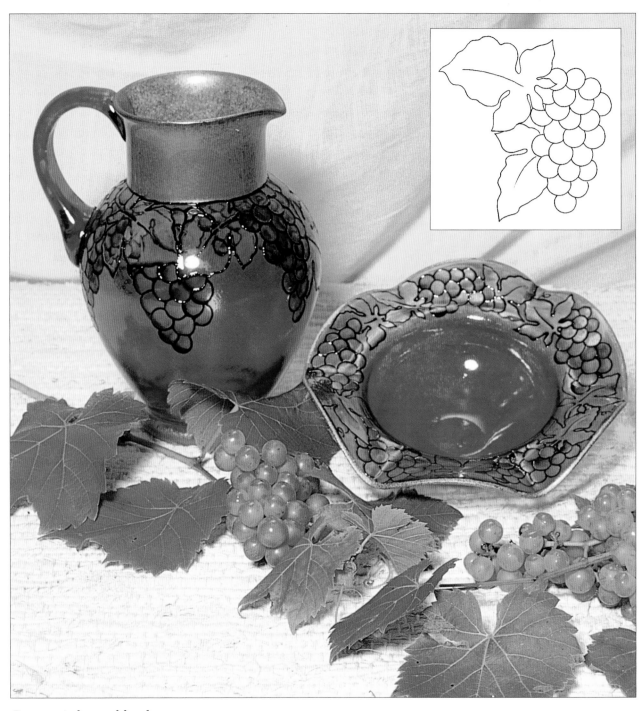

Roman pitcher and bowl

*A plain glass jug and bowl can be transformed with a simple vine motif.
The inside of the neck of this jug is sponged with gold outliner to add
extra sparkle.*

52

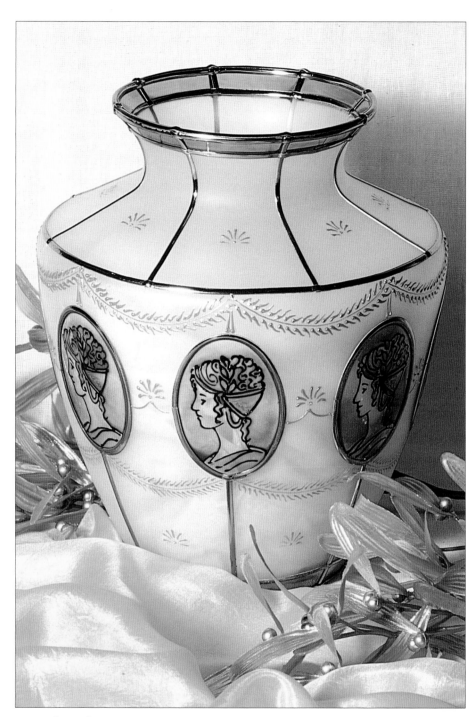

Frosted Greek urn

The eight ovals around this frosted vase are created using brass-effect self-adhesive lead. The Greek maidens are outlined and painted, and further intricate detailing is added using gold outliner.

Pattern for the chapter opening designs on pages 44–45

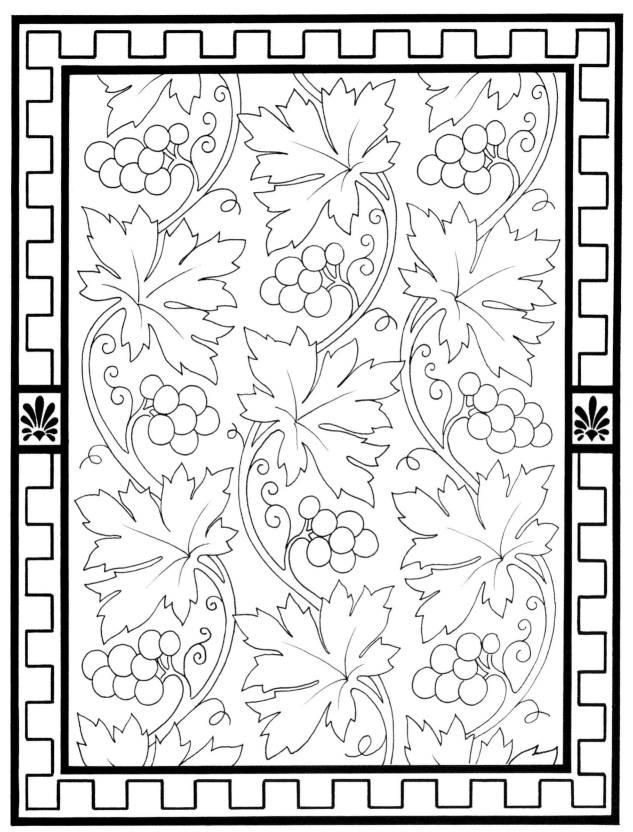

Pattern for the vine window on page 50

CHINESE
AND
JAPANESE

Floral plate

BACKPAINTING AND GILDING

The Far Eastern civilisation originated in China in 2200BC and spread to Japan in 600AD. The Chinese and Japanese cultures are renowned for their traditional arts. The Buddhist art that the Chinese brought back to the far east from India, was actually influenced by the Greek civilisation. In turn, Japanese art descended from the Chinese. From early times, skilled craftsmen produced artworks of a very high quality. Painting, sculpture, pottery, calligraphy, lacquer work and textiles all reveal the imagination, delicacy and dislike of straight lines in this very individual style of decoration.

Once again, symbolism is a very important part of Chinese and Japanese art. In no other part of the world are flowers so greatly appreciated. The chrysanthemum, although first grown in China, was widely cultivated in Japan and became the emperor's symbol in the fourteenth century. This flower, along with stylised interpretations of peonies, lotus blossom, pine and bamboo were frequently used on Japanese textiles and ceramicware. Chinese craftsmen used floral motifs to create a feeling of balance and harmony on their artifacts.

The dragon represents the country of China and is the symbol of spring and new life; the phoenix is the symbol of beauty and peace. When combined, these designs symbolise good luck and are often used in wedding decorations. These and other wonderfully stylised designs used in Chinese and Japanese art are a true gift to the glass painter.

FLORAL PLATE

Backpainting and gilding

The stylised flowers and leaves used to decorate this plate are brought to life with the addition of gold leaf. All the decoration is applied to the back of the plate so that the surface has a wonderfully flat finish and it is the glass itself that protects the decoration.

The plate I have used for this project is 23cm (9in) in diameter, but you can use any sized plate . . . just adjust the size of the pattern accordingly.

You will need

Glass plate

Black outliner

Solvent-based glass paint: green

Clear gloss varnish

Acrylic paint: red

9 sheets Dutch metal gold leaf

Gilding size

No. 2 and No. 6 paintbrush

Large soft paintbrush

Scissors

Masking tape

Palette

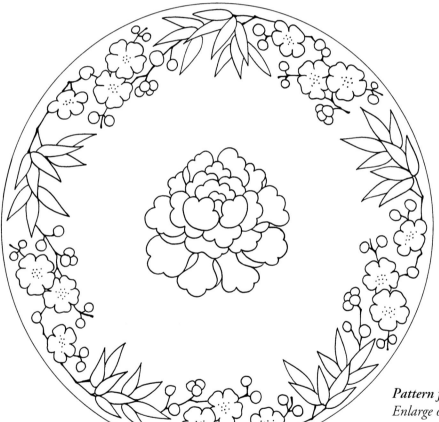

Pattern for floral plate
Enlarge on a photocopier by 160%.

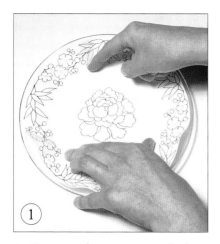

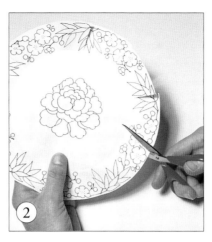

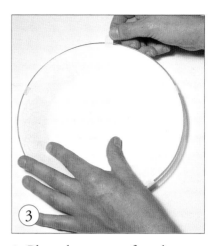

1. Cut out the pattern and place it face up on the plate. Run your finger around the edge of the base to form a crease in the paper.

2. Cut approximately ten equally spaced slits around the border design. Each slit should stop at the crease mark.

3. Place the pattern face down on the plate. Overlap the slits to enable the pattern to lie flat. Tape into place with small pieces of masking tape.

Note *Make sure that the masking tape does not obscure any of the design lines, as you will need to see these to outline them.*

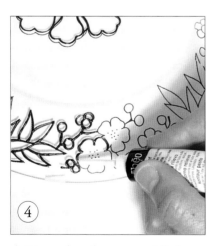

4. Turn the plate over. All the work is now done on the back of the plate. Outline the central flower then the border using black outliner. Leave to dry before removing the pattern.

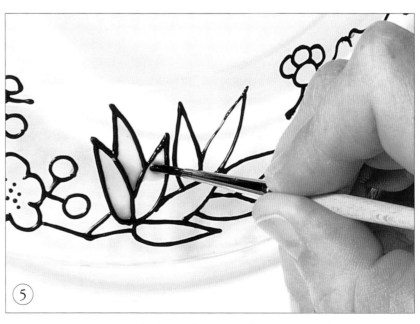

5. Mix green paint with clear gloss varnish to create a light green (see page 47). Use this colour and a No. 2 brush to paint in all the leaves. Allow to dry.

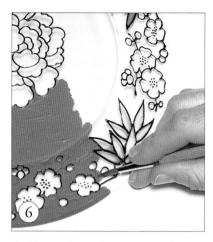

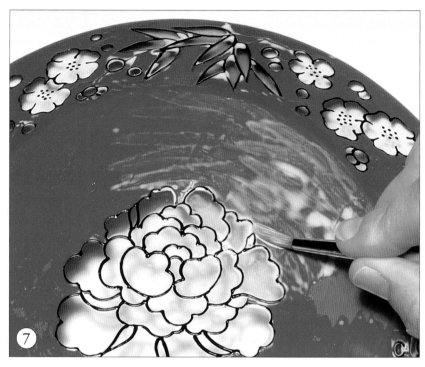

6. Use red acrylic paint and a No. 6 paintbrush to fill in the background. Leave the flowers and buds unpainted, but paint over the stems on the border. Leave to dry before applying a second coat. Leave to dry.

7. Use a No. 6 paintbrush to apply a thin coat of size all over the back of the plate. Leave to dry until the size goes clear – this should take between five and fifteen minutes, depending on humidity.

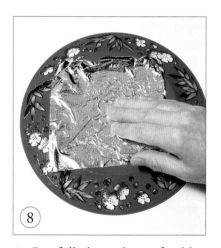

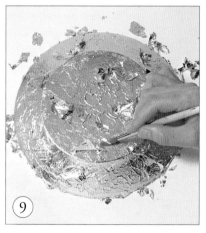

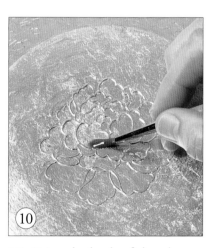

8. Carefully lay a sheet of gold leaf over the plate and press it gently with your fingers to adhere it to the size. Overlap the next sheet slightly, and continue adding sheets of leaf until the back of the plate is completely covered.

9. Smooth over the gold leaf with your fingers, pressing down firmly to flatten it. Remove any overlapping pieces of leaf with a large soft paintbrush. Fill in any gaps or cracks with size and small scraps of gold leaf.

10. Paint the back of the plate with a coat of clear gloss varnish to protect the gilding.

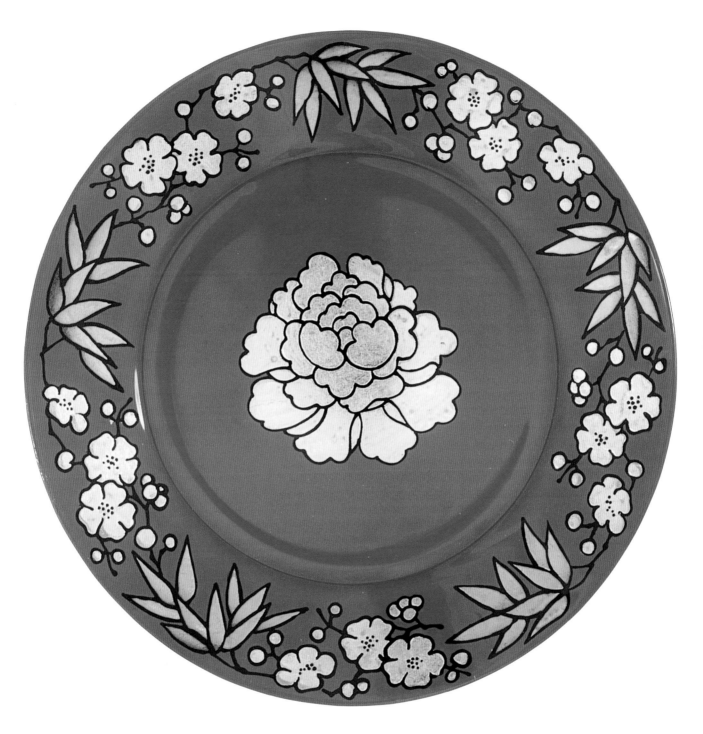

Floral plate
This plate is backpainted to achieve a truly flat finish. The contrast between the opaque red of the background and the brilliance of the gilded flowers and green leaves produces a very professional finish.

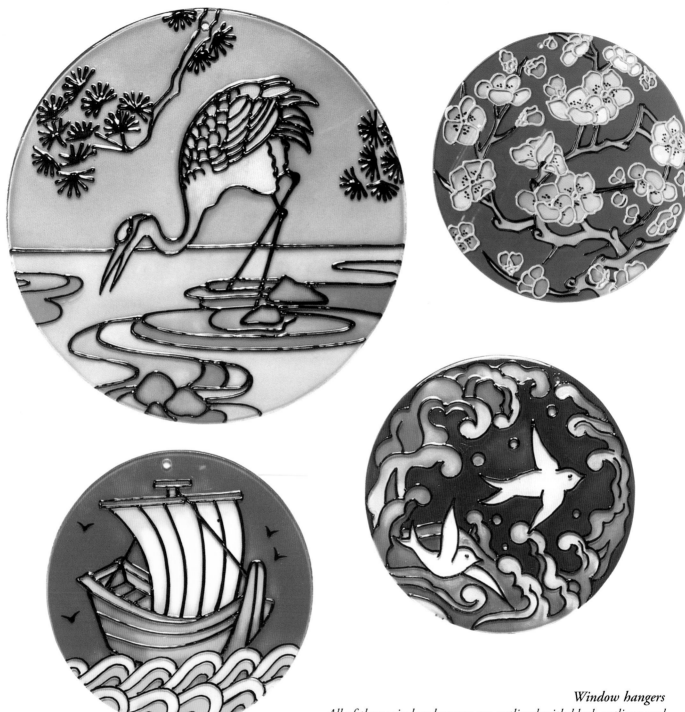

Window hangers

All of these window hangers are outlined with black outliner and then painted. To achieve the pastel colours of the stork window hanger, the paints are diluted with clear gloss varnish. The blossom on the floral hanger is re-outlined in gold once the paint is dry. These hangers can be threaded with coloured ribbon and hung up to add colour to any window.

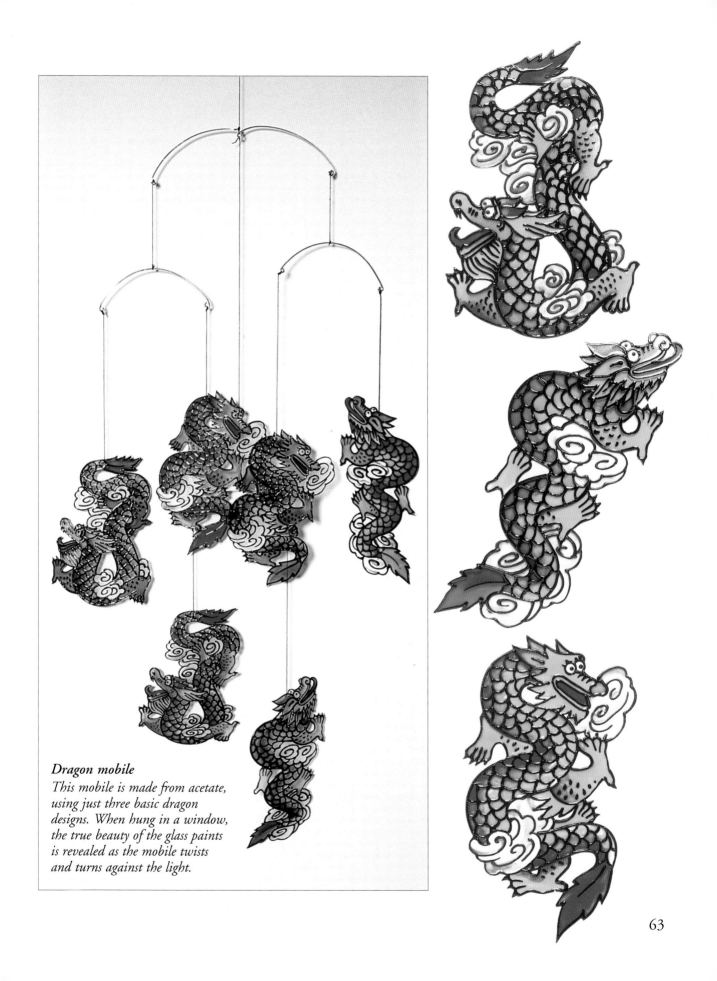

Dragon mobile
This mobile is made from acetate,
using just three basic dragon
designs. When hung in a window,
the true beauty of the glass paints
is revealed as the mobile twists
and turns against the light.

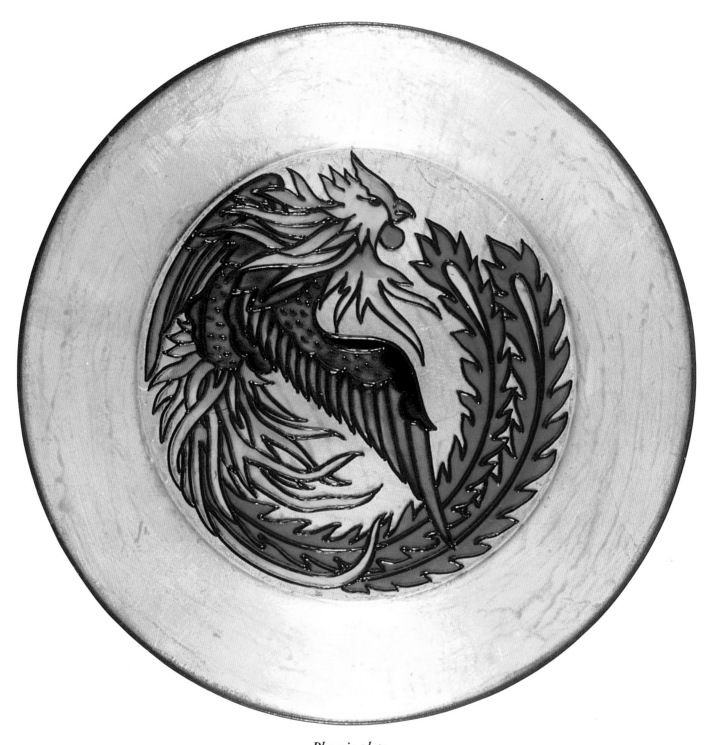

Phoenix plate
This colourful bird is outlined and painted on the face of the plate. The back of the plate is then gilded to add a rich lustre to the design.

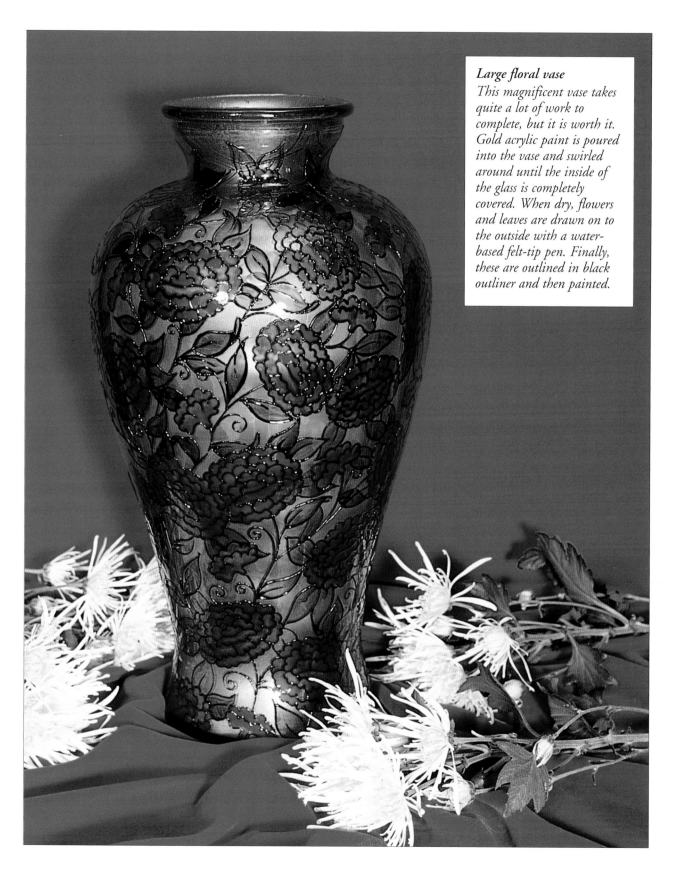

Large floral vase
This magnificent vase takes quite a lot of work to complete, but it is worth it. Gold acrylic paint is poured into the vase and swirled around until the inside of the glass is completely covered. When dry, flowers and leaves are drawn on to the outside with a water-based felt-tip pen. Finally, these are outlined in black outliner and then painted.

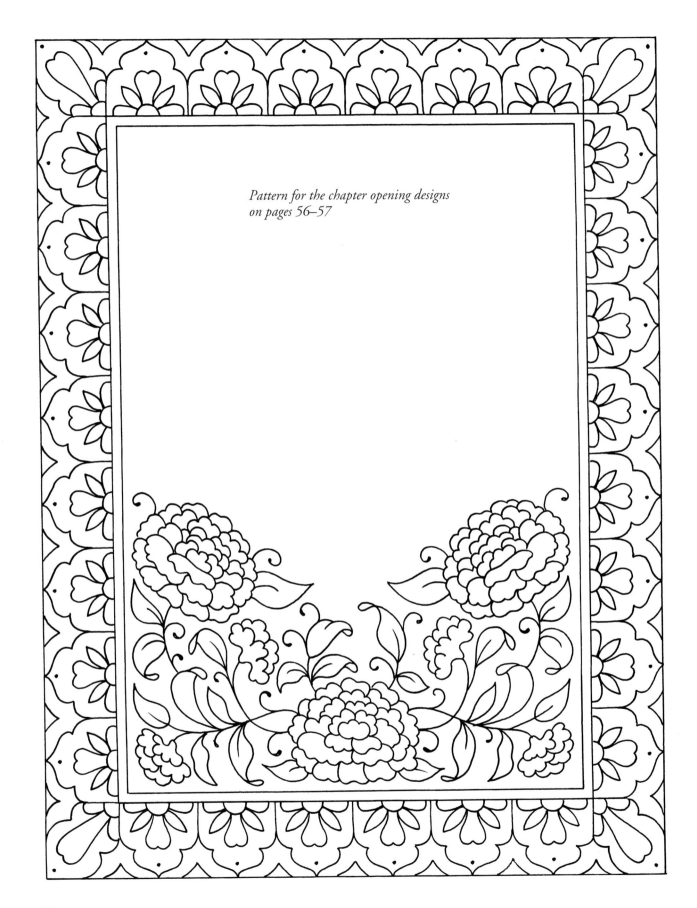

Pattern for the chapter opening designs on pages 56–57

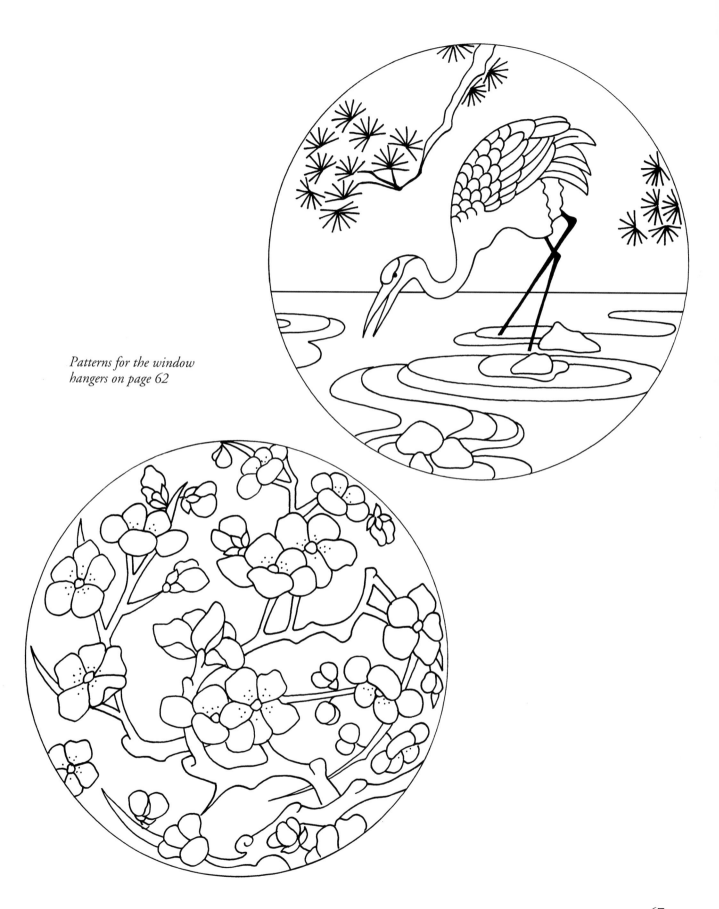

Patterns for the window hangers on page 62

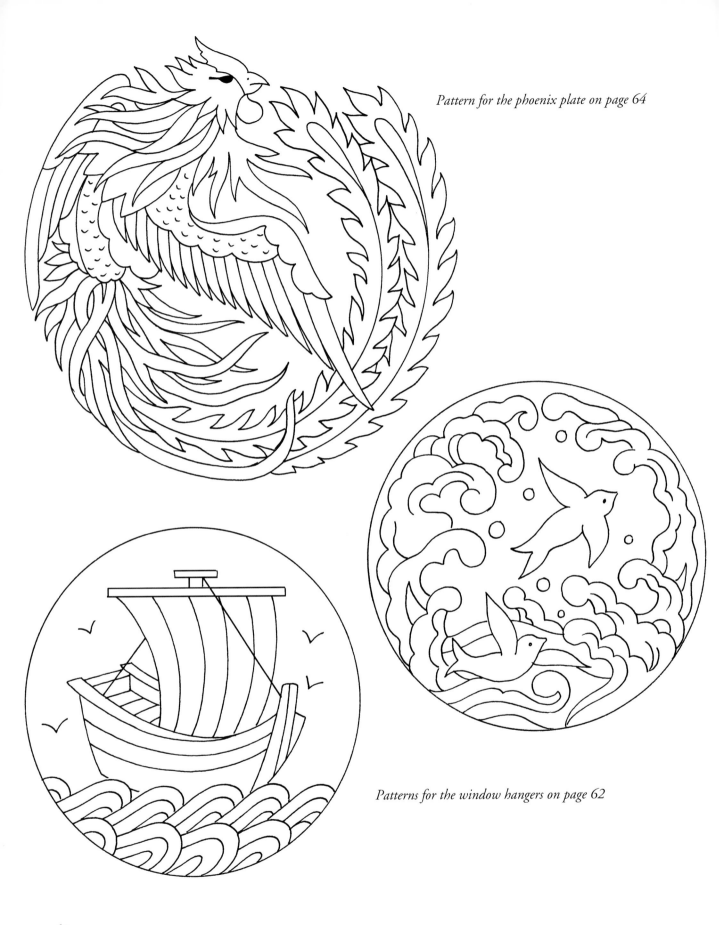

Pattern for the phoenix plate on page 64

Patterns for the window hangers on page 62

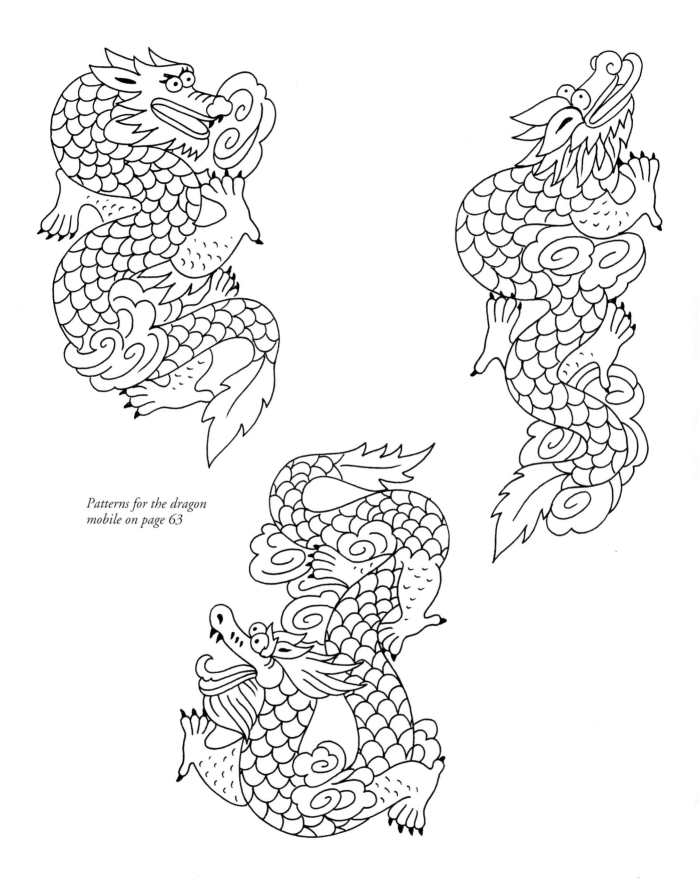

*Patterns for the dragon
mobile on page 63*

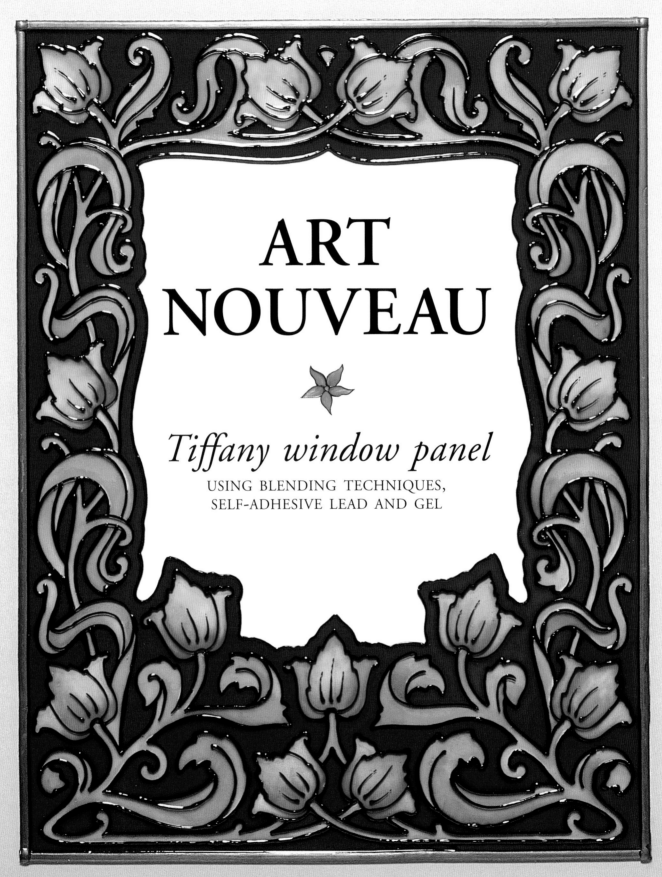

ART NOUVEAU

Tiffany window panel

USING BLENDING TECHNIQUES,
SELF-ADHESIVE LEAD AND GEL

In the last decade of the nineteenth century, artists were looking for new materials and a new style of art to welcome in the new century . . . and so was born the Art Nouveau period. Artists introduced flowing lines and intricate entwining patterns that had a beauty and symmetry that many found irresistible. Birds, animals, flowers and the human figure were all treated with these same flowing lines. The style soon spread across Europe and America.

Artists from this period believed that design could be applied to anything – a humble table lamp required as much thought and work as a painting or piece of sculpture. Louis Comfort Tiffany successfully translated the organic lines of the art nouveau style into his glass work to produce beautiful vases and window panels. As the electric light was born, he was able to explore a new avenue, and soon the name of Tiffany became linked with fabulous lamps. A Scottish designer called Charles Rennie Mackintosh was meanwhile producing a more stylised work with elegant lines and much simpler floral motifs.

Art Nouveau designs lend themselves perfectly to glass painting. You can emulate the Tiffany designs, transform a mirror or use the simpler motifs to decorate a humble bottle.

TIFFANY WINDOW PANEL
Using blending techniques, self-adhesive lead and gel

This is my favourite project as it gave me an excuse to immerse myself in the glorious works of Tiffany. His sense of design and use of colour were well balanced and he obviously understood the play of light on glass. This simple window panel uses self-adhesive lead as a border to give the panel an antique quality. The blending technique on the leaves and flowers and the application of clear gel adds texture and brings life to the whole panel. It is important to wipe the glass with methylated spirit or lighter fluid before you begin the project to ensure that the lead will stick to the glass.

Note The blending technique requires a liberal application of the glass paints. You may find it easier to work small sections at a time, leaving each to dry before moving on to the next area.

You will need
25 x 20cm (10 x 8in) clip frame or piece of glass

Black outliner

Self-adhesive lead, 3.5mm (0.140in) wide

Boning tool

Solvent-based glass paints: yellow, orange, red, turquoise, green and dark blue

Solvent-based clear gloss varnish

Clear water-based glass painting gel

No. 4 and No. 6 paintbrush

White paper

Scalpel

Cutting mat

Masking tape

Palette

Pattern for the Tiffany window panel
Enlarge on a photocopier by 180%.

72

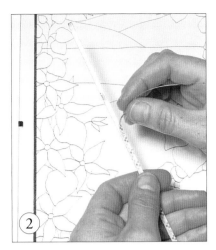

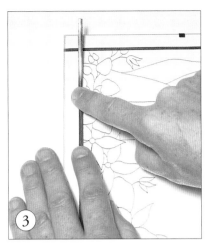

1. Place your design under the glass and tape into position with small pieces of masking tape. If you are working on a clip frame, use the clips to hold the design in place. Use a scalpel and a cutting mat to cut two 26cm (10½in) and two 21cm (8½in) strips of self-adhesive lead.

2. Remove the backing paper from one 26cm (10½in) length of lead. Use your pattern as a guide and lay the strip over the left-hand vertical border.

Note If the lead develops a kink in it, hold one end and pull the other to stretch and straighten it.

3. Press the lead strip on to the glass with your finger, allowing the ends to overhang the glass slightly. Use the boning tool to rub it flat against the glass (see page 8). Repeat with the other 26cm (10½in) strip for the right-hand vertical border.

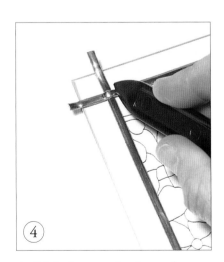

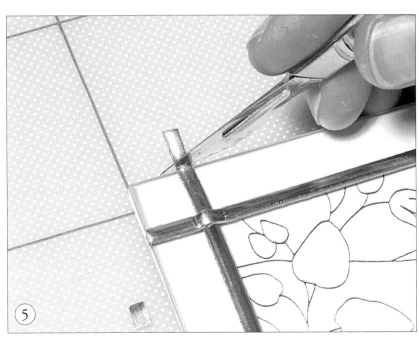

4. Stick the two horizontal 21cm (8½in) lengths on to the glass and use the boning tool to press the lead flat on to the glass. Press firmly where the strips cross one another.

5. Cut off the excess lead overhanging the glass with a scalpel.

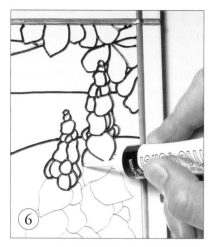

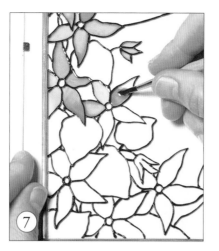

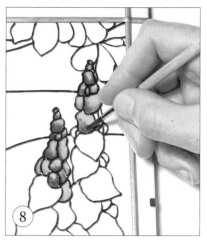

6. Outline the design with black outliner and allow to dry. Remove the pattern and lay the glass on a sheet of white paper.

7. Decant some turquoise paint into a palette. Mix in a little clear gloss varnish to lighten the colour. Use a No. 4 paintbrush to paint the clematis flowers. Add orange centres.

8. Paint one of the hollyhocks yellow and while the paint is still wet add touches of orange and red. Blend the paints into one another (see page 36). Repeat to fill in all the hollyhocks.

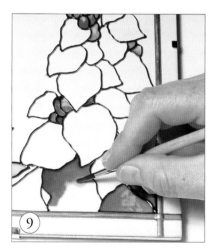

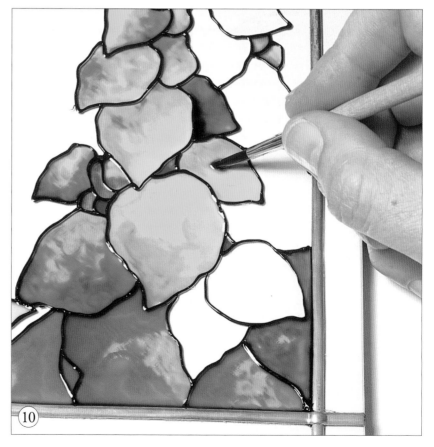

9. Paint the foliage at the top right and across the bottom of the design using turquoise and yellow merged together on the glass. Allow to dry.

10. Paint all the remaining leaves using yellow and green and the blending technique.

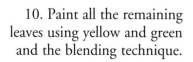

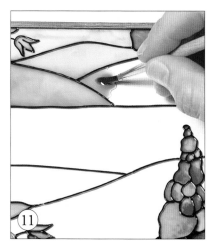

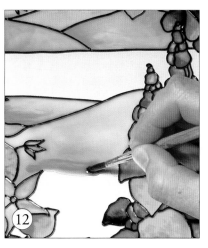

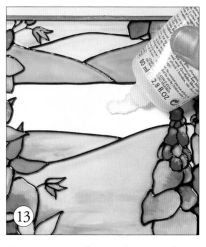

11. Mix a drop of turquoise with clear gloss varnish on a palette. Use a No. 6 paintbrush to fill in the sky area. Paint the distant hills in varnish mixed with a few drops of green.

12. Paint the hills in the foreground using the same mixture of clear varnish and green. As you work down this area, add a little turquoise to darken the colour.

13. Squeeze clear gel on to the lake area and use a No. 6 paintbrush to spread the gel around the lake area.

14. Lightly drag the brush across the surface of the wet gel to create the impression of ripples. Allow to dry.

15. Paint the corner sections red and fill in the outer border with dark blue. Leave to dry.

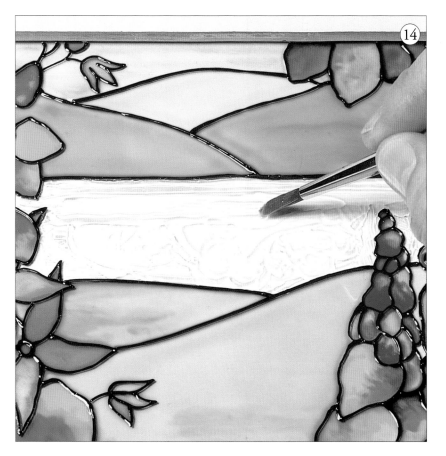

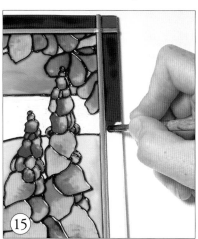

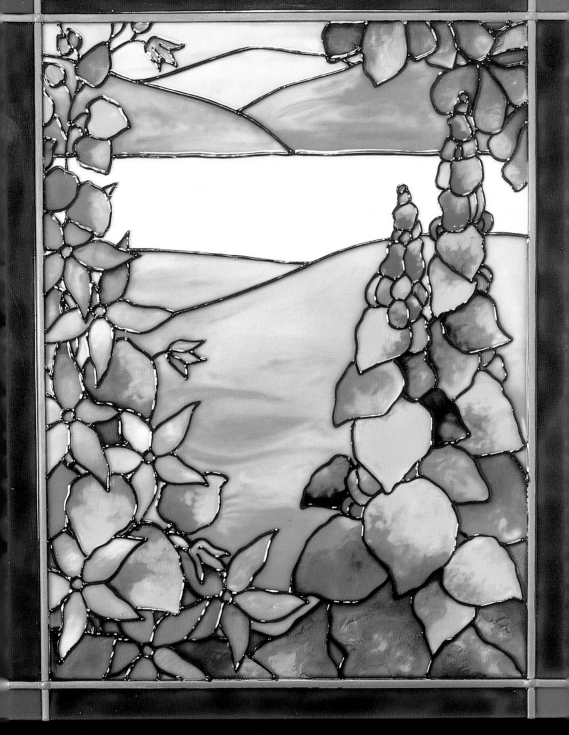

Tiffany window panel

This window panel project provides you with all the basic techniques to go on to create something a bit more elaborate, as shown on the opposite page. All you need is a little more of everything, and a touch of imagination!

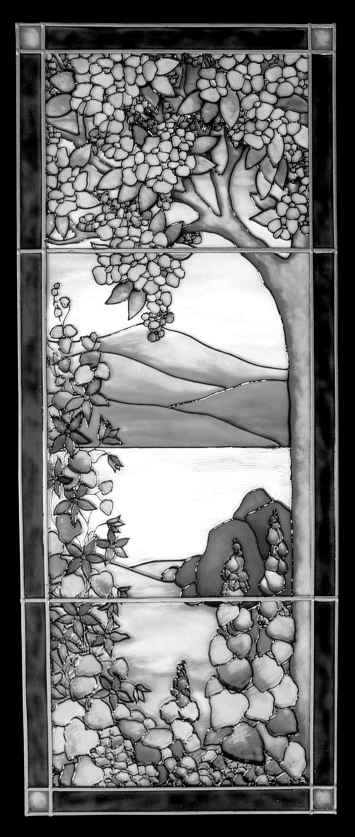

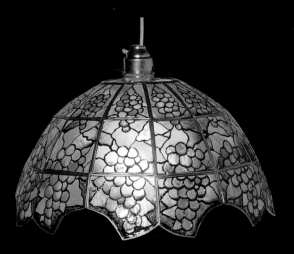

LEFT
Variation on the Tiffany window panel
This panel uses exactly the same techniques as the panel in the project, but it is worked on a larger scale.

Rose panel
The edge of this textured plastic roundel is decorated with self-adhesive lead. The design is outlined in black and painted. The roses are worked using white glass paint mixed with a little red.

Tiffany lampshade
You do not always need to work directly from a pattern when glass painting. The vine design here is drawn freehand on to the plastic lampshade. It is then outlined in black and painted.

Mackintosh-style panel
Self-adhesive lead is used to outline this elegant design. The roses, leaves and small square are painted and, when dry, the backgrounds are added using matt varnish marbled with spots of paint (see page 13).

Mackintosh-style bottles
Start saving all your empty bottles! The addition of gel, beads and shaped wire flowers can add a touch of class to any plain bottle. Let the shape of the bottle help you with the decoration.

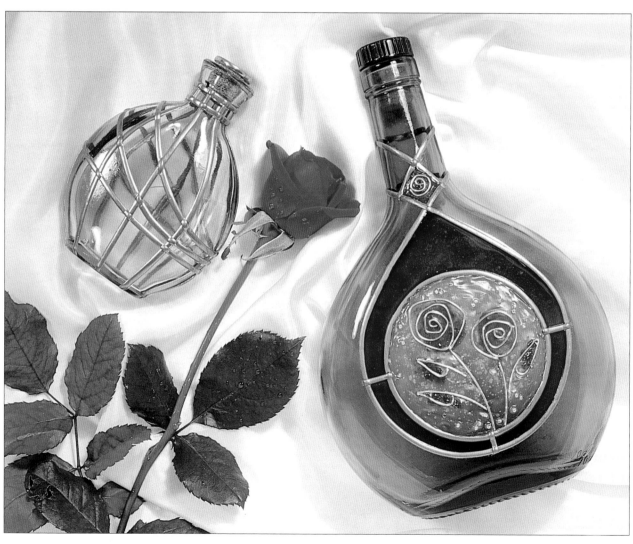

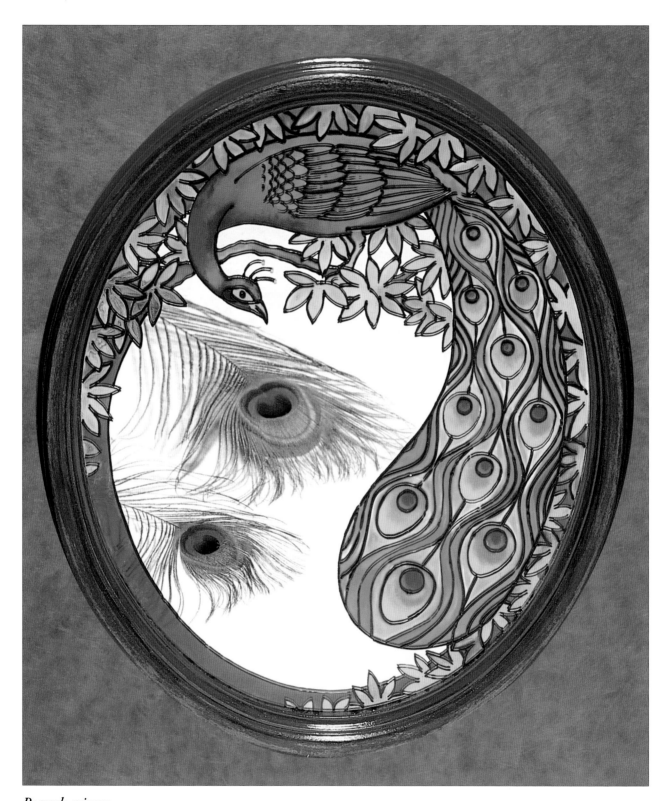

Peacock mirror
The peacock design is transferred on to the mirror using carbon paper. The frame
itself is painted with glass paint to complement the colours of the peacock.

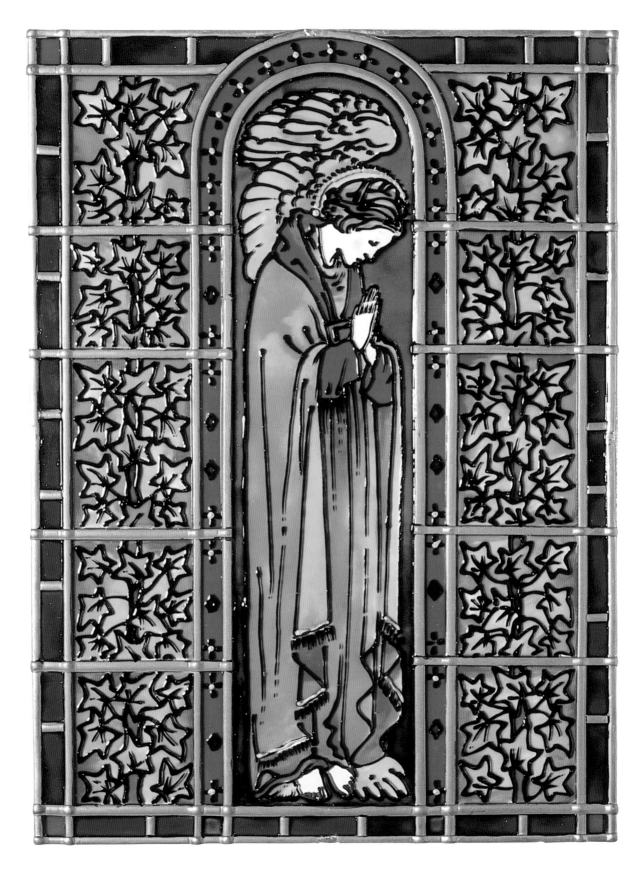

OPPOSITE
Angel clip frame
An intricate design such as this requires careful
planning and good control of the outliner. Work
the panel in stages to avoid smudging.

Pattern for the chapter opening
designs on pages 70–71

Pattern for the rose
panel on page 77

*Pattern for the peacock
mirror on page 79*

VICTORIAN

Rose bowl

SPONGING, FROSTING
AND USING GOLD OUTLINER

Queen Victoria ruled over Great Britain for sixty-four years, from 1837 until 1901. This was a period of great new discoveries and inventions. The Victorians were the first to introduce art galleries and museums to Britain, making art more accessible to the public. Skilled artists and craftsmen produced beautiful paintings, sculpture and architecture and they also introduced the art of photography. They were able to use a wonderful range of colours, made possible by advances in chemical and dyeing techniques. The Victorians used glass to great effect, especially in the Crystal Palace which required more than 300,000 panes of glass in its construction. We can still see examples of their use of patterned and etched glass in doors and windows today, and they show us that the Victorians were not afraid of strong design and bold colour.

The Victorians delighted in sentimentality and romance, as demonstrated by their extensive use of 'scraps' to decorate various items. The scraps the Victorians used consisted of coloured and embossed pre-cut paper designs depicting children, cherubs, flowers, butterflies and birds. These were used to cover a variety of items, including boxes, table tops, screens and Christmas decorations.

We are truly spoilt for choice in this period. A colourful window panel with bold lines and rich colours, or a more delicate approach using frosted glass paints and delicate floral decoration . . . the choice is yours.

ROSE BOWL

Sponging, frosting and using gold outliner

Traditional glass painting uses rich colours and bold designs. A more subtle look can be achieved with the use of matt varnish – which gives a delicate frosted effect – and metallic outliner. The floral border in this project has to be painted before adding the metallic outline, to prevent the paints from colouring the outline. I have also incorporated sponging, which serves to soften the outline of this Victorian bowl. It is important to work quickly when sponging with water-based paints, as they can dry very quickly, leaving lines.

Before you start, photocopy the design several times and join the pieces together with masking tape to form a strip that will fit comfortably around the inside of your bowl. Protect the bowl and prevent it from rolling off your work surface by placing it in a nest of fabric – an old towel or cotton sheeting is ideal.

You will need

Glass bowl

Water-based glass paints: pink and green

Water-based matt varnish

Gold outliner

1cm (½in) masking tape

Piece of sponge

No. 4 paintbrush

Palette

Scissors

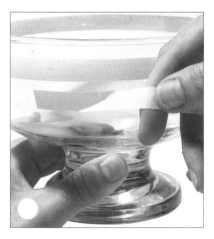

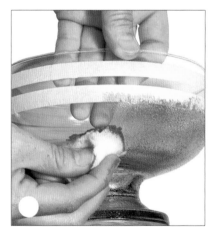

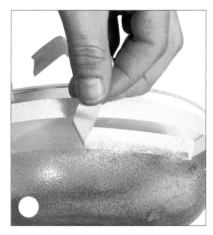

1. Apply two bands of masking tape around the bowl, to create a border just wider than the design. Press the edges of the tape flat against the bowl to prevent paint from seeping underneath in later stages.

2. Decant a little pink paint into a palette. Dab the sponge into the paint, and then sponge over the base and the outside of the bowl, up to the masking tape.

3. Carefully peel off the bottom strip of masking tape. It is important to do this before the paint is dry. Leave to dry.

Pattern for the floral bowl
Enlarge on a photocopier to a size suitable for your bowl.

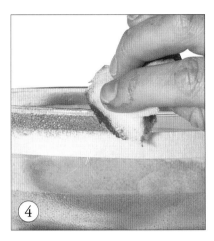

4. Hold the bowl by the base to sponge the 1cm (½cm) strip around the top of the bowl. Remove the masking tape and leave to dry.

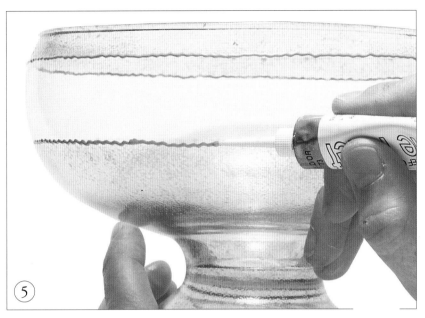

5. Outline each edge of the plain glass border with a wavy line of gold outliner. Leave to dry.

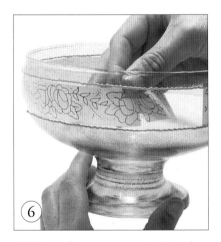

6. Place the pattern strip inside the bowl so that the design shows through the plain glass border. Cut slits in the paper if necessary (see page 59), to make the border lie flat against the bowl. Use small pieces of tape to secure the pattern in place around the border.

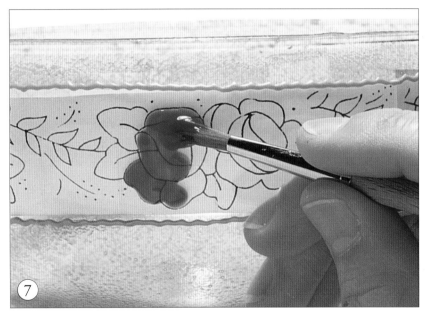

7. Paint all the roses pink using a No. 4 paintbrush. Do not worry if the painting does not exactly marry up with the pattern – this is intended as a guide only. Leave to dry.

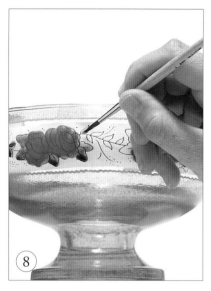

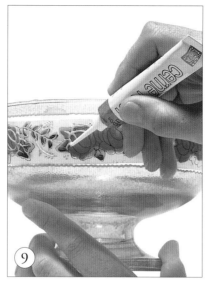

8. Paint all the leaves green using a No. 4 paintbrush. Leave to dry.

9. Outline the design with gold outliner. Add tendrils and dots as you work around the bowl. Leave the outliner to harden.

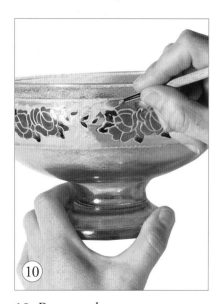

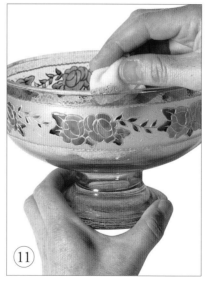

10. Remove the paper pattern. Fill in the background on the border with matt varnish. Paint over the tendrils and dots and up to the outlined leaves and roses. Leave to dry.

11. Squeeze a little gold outliner on to a palette and sponge this around the rim of the bowl.

Floral bowl
You can create a soft pastel appearance by using gold outliner and matt varnish. This glass bowl is sponged to create texture on the surface of the glass. The matt varnish does not have to be used in conjunction with outliner. Try painting or sponging it directly on to glass to create a delicate background.

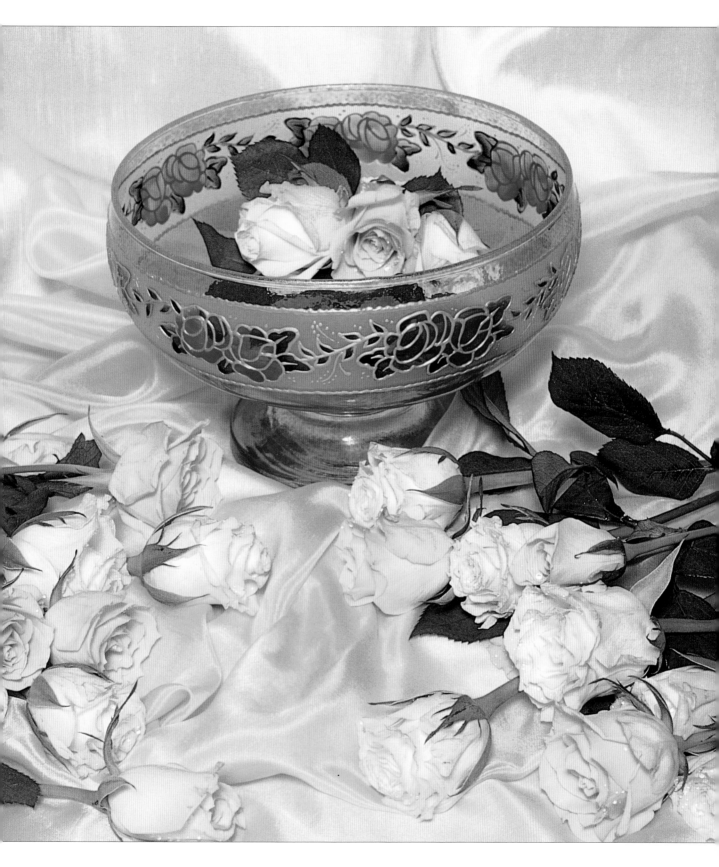

Heart boxes

These heart boxes are all decorated using simple techniques, including sponging with matt varnish and adding detail with metallic outliner. The result is a collection of charming boxes that would make ideal gifts.

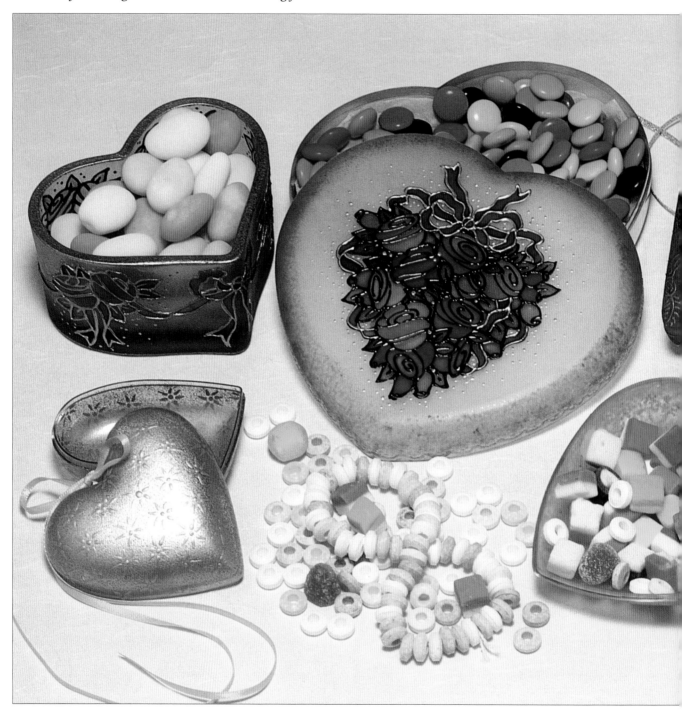

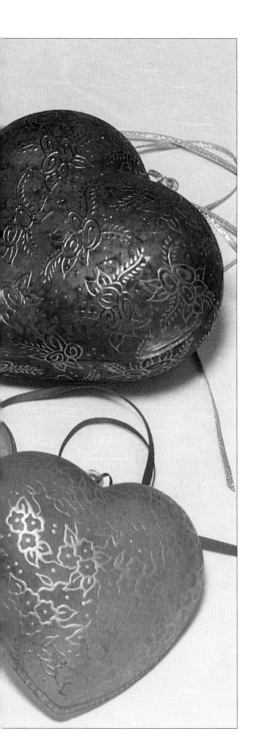

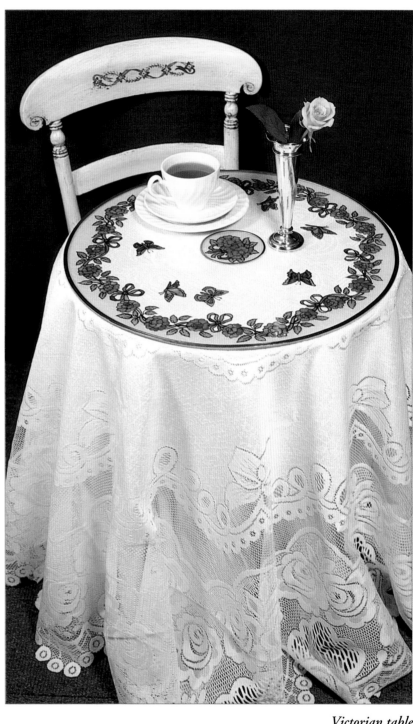

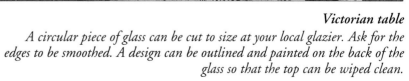

Victorian table
A circular piece of glass can be cut to size at your local glazier. Ask for the edges to be smoothed. A design can be outlined and painted on the back of the glass so that the top can be wiped clean.

91

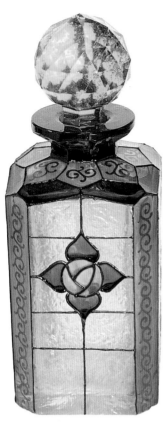

Victorian decanter
An old decanter can be transformed with today's glass paints. The central panels of this decanter are dabbed with clear glass-painting gel to complete the decoration.

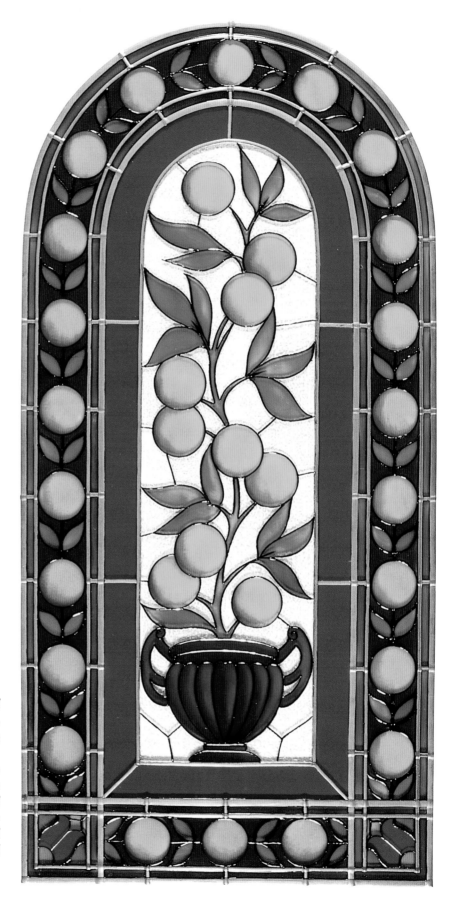

Victorian arched window panel
The basic border structure in this design is created using two different widths of self-adhesive lead. Oranges, leaves and the vase are outlined in black and the panel is then painted. A paintbrush is used to dab clear glass-painting gel on to the background behind the central panel to achieve an unusual textured finish.

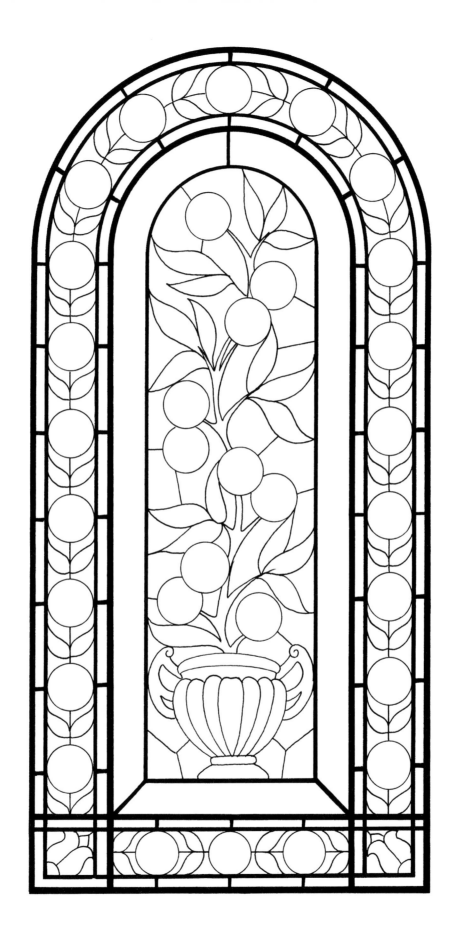

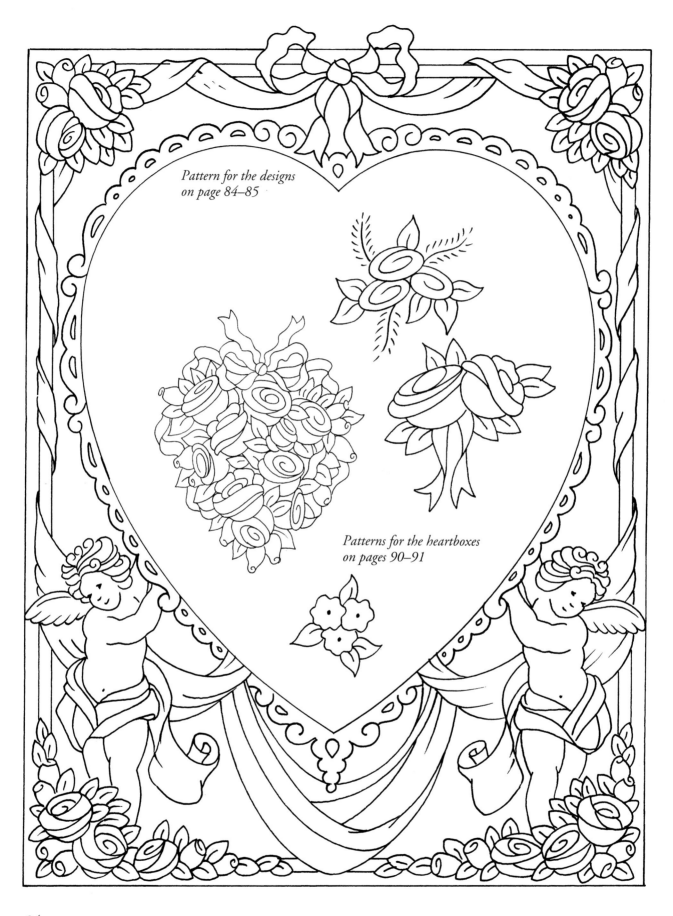

Pattern for the designs
on page 84–85

Patterns for the heartboxes
on pages 90–91

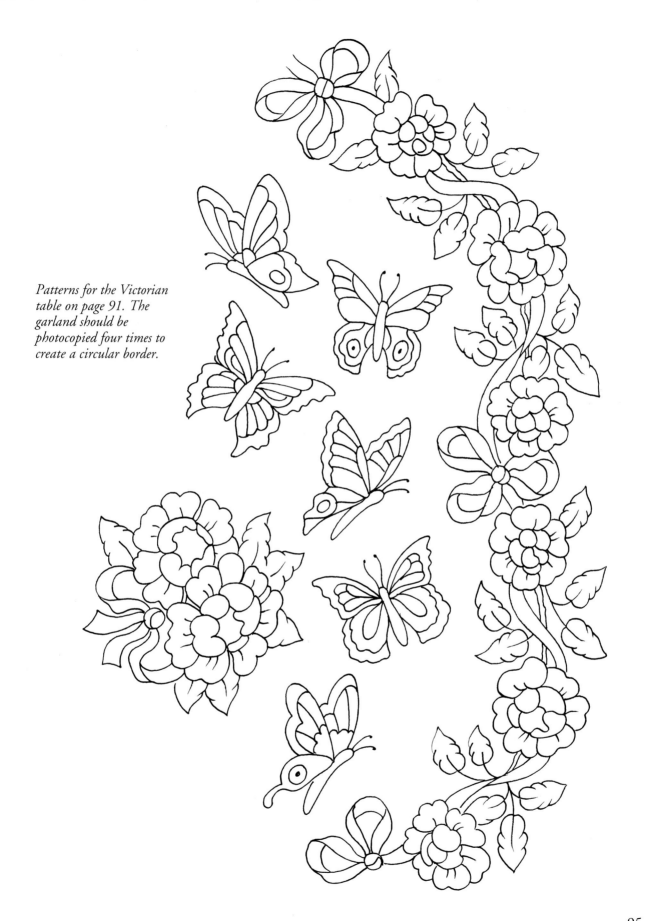

Patterns for the Victorian table on page 91. The garland should be photocopied four times to create a circular border.

INDEX